PAINTING WITH
BOB ROSS®

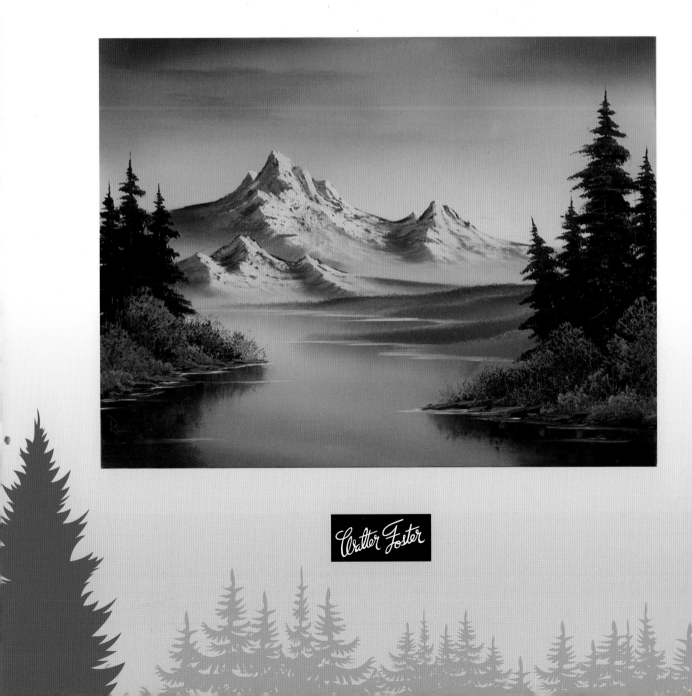

Brimming with creative inspiration, how-to projects, and useful information to enrich your everyday life, quarto.com is a favorite destination for those pursuing their interests and passions.

First published in 2018 by Walter Foster Publishing, an imprint of The Quarto Group.
100 Cummings Center, Suite 265D, Beverly, MA 01915, USA.
T (978) 282-9590 **F** (978) 283-2742 **www.quarto.com** • **www.walterfoster.com**

Walter Foster Publishing titles are also available at discount for retail, wholesale, promotional, and bulk purchase. For details, contact the Special Sales Manager by email at specialsales@quarto.com or by mail at The Quarto Group, Attn: Special Sales Manager, 100 Cummings Center, Suite 265D, Beverly, MA 01915, USA.

ISBN: 978-1-63322-652-4

Instructional Author: Annette Kowalski
Progressional Paintings: Carolyn Saletto, CRI
Technical Assistance: Doug Hallgren, CRI, and Nic Hankins, CRI

Printed in China
20 19 18 17 16 15

TABLE OF CONTENTS

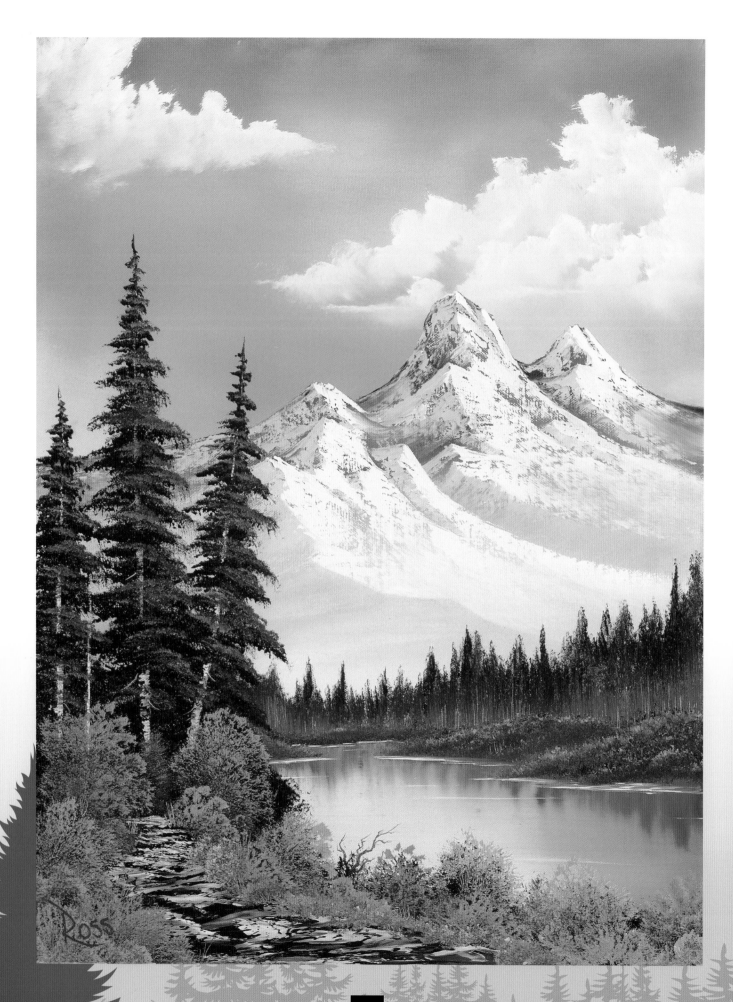

THE BOB ROSS STORY

You've seen him before. He's the soft-spoken guy painting happy clouds, mountains, and trees in about 26 television minutes, using big house-painting-type brushes and cooing soothing "you can do its" to his audience. Bob Ross' *Joy of Painting* program is the most recognized, most watched TV art show in history.

Millions of viewers of all ages and from around the globe still relax and unwind with Bob's gentle manner and encouraging words, captivated by the magic that takes place on canvas. His quiet, nurturing disposition is a form of therapy for the weary, and his respect for nature helps environmental awareness.

Bob Ross was born in Daytona Beach, Florida, on October 29, 1942. He grew up in Orlando with his father, Jack, a carpenter, and his mother, Ollie, who had the largest influence on him. She taught him to love wildlife. "I think when I was a kid, I must have had every kind of pet imaginable," Bob said.

At 18, Bob joined the Air Force, and after a couple of years was transferred to Alaska. Having been born and raised in Florida, Bob Ross was 21 years old when he saw snow for the first time. And yet that breathtaking Alaskan scenery, and the sights of nature in the years following, would serve as his ultimate inspiration on canvas.

For more than 35 years, Bob Ross has transformed TV viewers into canvas champions. Folks who never thought to pick up a paintbrush before decided to paint because of Bob Ross.

Bob was always proud of the fact that while art has traditionally been accessible to only a select few, his technique brings everyone to the table. "Talent is nothing more than a pursued interest," he would often say. "All you need to paint is a few tools, a little instruction, and a vision in your mind."

And if you're reading this, then you probably already have the vision. Watching Bob Ross on television will do that to you: open your eyes and make you see things about yourself that you hadn't before.

The Bob Ross Company was formed in 1981 and is an active behind-the-scenes organization that today celebrates more than 35 years of operation, even after the death of Bob Ross in 1995. His company is as strong and dedicated as ever to his philosophy of bringing art to the masses, and his painting show continues to air—uninterrupted since 1982— all over the world.

"Let me extend a personal invitation for you to drag out your brushes and a few paints and paint along with us..." — *Bob Ross*

TOOLS & MATERIALS

To achieve all those amazing effects that you see Bob Ross do on canvas, use his specially designed materials: uniquely formulated Bob Ross paints, mediums, brushes, knives, and canvases. He carefully developed the tools and colors that can properly produce the Bob Ross Wet-on-Wet Technique®.

But that doesn't mean you can't still enjoy using this instructional book to create masterpieces with other tools and paints. You will benefit richly from his motivational spirit, his encouraging words, and lovely landscape compositions, no matter what you're painting with! Put your dreams on canvas with television's favorite artist, Bob Ross.

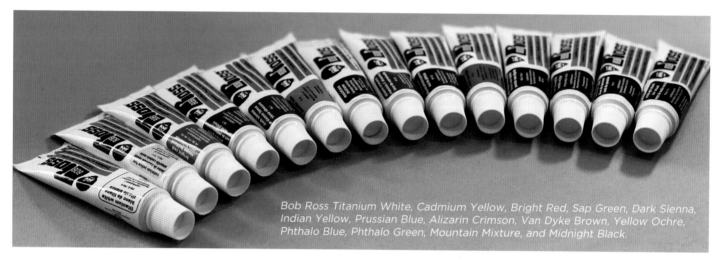

Bob Ross Titanium White, Cadmium Yellow, Bright Red, Sap Green, Dark Sienna, Indian Yellow, Prussian Blue, Alizarin Crimson, Van Dyke Brown, Yellow Ochre, Phthalo Blue, Phthalo Green, Mountain Mixture, and Midnight Black.

Paints

Bob carefully chose the colors in his line because they "play well with each another" in creating natural-looking landscape tones with ease. If you use other water-based or traditional oil paints, note that while they may carry the same color name, their actual hues can be different.

If you use Bob Ross brand paints, you can follow the steps in this book and create all the desired effects without any adjustments. You can use any paint you'd like, of course, but you'll need to adjust the color and application to achieve the desired effect. For example, if you are using acrylics, this will affect the blended areas. They won't be as soft as Bob's paintings because acrylics dry quicker. And if you use traditional oil paints, keep in mind that they are softer, and the effect created when tapping in those sparkly foliage highlights onto the dark undercolors will not be the same.

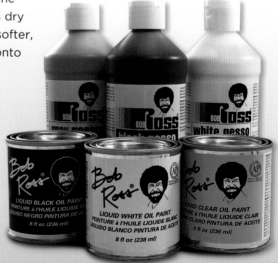

Basecoats

Before you start painting, you will need to prepare your canvas with a basecoat. If it's Gray, White, or Black Gesso, you must let these dry before you proceed. If it's Liquid White, Black, or Clear, you must allow these to remain wet when you start painting. Follow the directions carefully for the best results.

Left to right: Gray Gesso, Black Gesso, White Gesso (back row), Liquid Black, Liquid White, Liquid Clear (front row).

Paintbrushes

Bob's natural-bristled brushes vary in size, shape, and texture. They were carefully designed by Bob himself, and much of his technique depends on how paint is loaded onto them. Follow his instructions and you will create amazing effects on canvas. If you do decide to use other brushes, particularly synthetic brushes, avoid letting those nylon or polyester bristles "cut" into your strokes on the canvas; they are unsightly and difficult to buff out.

Here are the brushes used in this book:

1-inch landscape brush for applying Liquid White (Black, Clear); painting clouds, skies, water, trees, bushes

2-inch background brush for the same as the 1-inch brush, but for larger areas

1-inch round brush for clouds, foothills, trees, bushes

Half-size round brush for trees, bushes, foliage in smaller areas

#6 fan blender brush for clouds, mountains, tree trunks, foothills, soft grassy areas

#3 fan blender brush for the same effects as the larger #6 fan brush, but for smaller areas

#6 filbert bristle brush for seascapes, tree trunks, other small detail work

#2 script liner brush sticks, twigs, limbs and details, including your signature

1-inch oval brush for evergreen trees and foothills, highlighting trees and bushes

1-inch landscape brush

2-inch background brush

1-inch round brush

Half-size round brush

#6 fan blender brush

#3 fan blender brush

#6 filbert bristle brush

1-inch oval brush

#2 script liner brush

Painting Knives

Bob's painting knives are used for both mixing colors on your palette and also for painting your masterpiece! These knives are uniquely designed to have just the right amount of "bend" and blade. The small knife is good for tiny mountain and trunk areas.

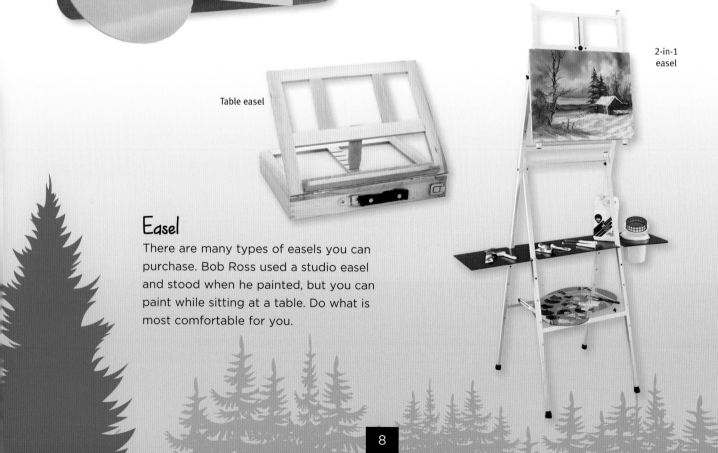

Palette

Whatever type of palette you choose—glass, wood, plastic, or paper—make sure it is easy to clean and large enough for mixing your colors. Glass is a great surface for mixing paints and is very durable. Palette paper is disposable, so cleanup is simple, and you can always purchase an airtight plastic box (or paint seal) to keep your leftover paint fresh between painting sessions. Bob Ross used a roomy Clear Acrylic Palette; if you are using oil paints, do not use a wooden palette, as it will soak the oil out of your colors.

Table easel

2-in-1 easel

Easel

There are many types of easels you can purchase. Bob Ross used a studio easel and stood when he painted, but you can paint while sitting at a table. Do what is most comfortable for you.

Canvas

The surface on which you paint is called the "support"—generally canvas or wood. You can stretch canvas yourself, but it's simpler to purchase prestretched, preprimed canvas (stapled to a frame) or canvas board (canvas glued to cardboard). All of the projects in this book require an 18" x 24" canvas. Avoid using canvas boards—they steal oil right out of your colors! Use double-primed, gray-tinted, prestretched canvases that are very tight on the stretcher bars.

Brush Cleaning

Clean your brushes after each use to keep them in good condition. Remove oil paint with odorless thinner, following the label directions carefully. Then wipe the brush dry with a soft cloth or paper towel. You can use a disposable baby diaper to thoroughly soak out and remove thinner from the big brushes. Finish by massaging a gentle brush conditioner into the bristles. If you are using Bob's natural bristle brushes, do not use water to clean them. Water and water-based solvents will ruin the bristles.

Cleaning Supplies

Painting can be messy, so it's a good idea to keep paper towels or rags close by to clean your painting area as needed. Here's a great tip: cover your hands generously with a creamy skin lotion before you start painting. This will make washing your hands afterward much easier.

BASIC PAINTING TECHNIQUES

Oil painters apply paint to their supports with brushes and painting knives. The variety of effects you can achieve—depending on your tool selections and techniques—are virtually limitless.

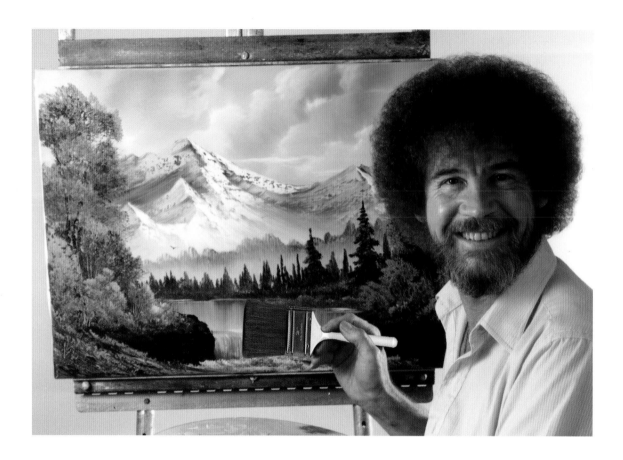

Using the Wet-on-Wet or Alla Prima Method

The Bob Ross Wet-on-Wet Technique® is sometimes called *alla prima* (Italian for "at once"). This means that you apply all the paint in a single session, instead of waiting for each phase to dry before continuing to the next. Bob's all-at-once quick way of painting does require you to first make the canvas wet. For this, apply a thin even basecoat of one of his special "Liquid formulas" (see page 6) using the 2-inch brush. Additionally, you need a special firm oil paint for the base colors (also on page 6). Colors that are used primarily for highlights (yellows) are manufactured to a slightly thinner consistency for easier mixing and application. Thin paint will stick to a thick paint; this is the basic premise for any alla prima method.

If you want your paintings to look just like Bob's, then using his equipment ensures the best possible results. But you can use anything you want because there are a lot of ideas and wonderful words of encouragement in this book, even if the technique you use is not the same.

There are no great mysteries to painting. You need only the desire, a few basic techniques, and a little practice. Use each step-by-step painting as a learning experience, add your own ideas, and your confidence as well as your ability will increase at an unbelievable rate.

Loading Your Paintbrush or Knife

Here are some tips for loading your brushes and painting knives.

Turning Use a liner brush to paint small details and apply your signature to your paintings. Thin your paint mixture to an ink-like consistency by dipping the liner brush into paint thinner. Then slowly turn the brush as you pull the bristles through the mixture, forcing them to a sharp point. Apply very little pressure as you add the final details to your painting.

Angling & Sliding Load your brush by holding it at a 45-degree angle and tapping the bristles into your paint. Allow the brush to "slide" slightly forward in the paint each time you tap. This ensures that the very tips of the bristles are fully loaded with paint.

Tapping Firmly Tap the bristles firmly against the palette to ensure an even distribution of paint throughout the bristles.

Loading Two Colors at Once Add highlights and shadow with one stroke by double-loading your brush. Load the brush with dark color, and then pull one side of the bristles through a mixture of your highlight color. Use a single, curved stroke to shape rocks. Shape trees by holding the brush vertically, with the light side of the brush on the side of the light source, and tap downward.

You can also add two highlight colors at once to trees and bushes. With the handle straight up, pull the brush (several times in one direction to round one corner of the bristles) through your first highlight color. Touch just the rounded corner of the brush into a very thin mixture of the second highlight color. With the rounded corner of the brush up, force the bristles to bend upward to highlight the individual trees and bushes.

Painting with a Knife

Pull your paint mixture out very flat on your palette, hold the knife straight up and "cut" across the mixture to load the long edge of the blade with a small roll of paint. Holding the knife straight up will force the small roll of paint to the very edge of the blade.

To paint tree bark, mountain highlights, rocks, and ground areas with a knife, use long, even strokes and very little pressure, which allows the paint to "break," letting the darker color create shadowed areas. Use the angles of the knife strokes to create the lay of the land.

Here are some effects you can achieve with a painting knife.

PAINTING HAPPY TREES, MOUNTAINS & MORE

Happy Trees

In almost every Bob Ross painting, there is a happy little tree. Throughout this book, you may refer back to the technique explained here to paint your evergreen trees. You will need a fan brush and a knife for this technique. Depending on the painting, your colors may vary.

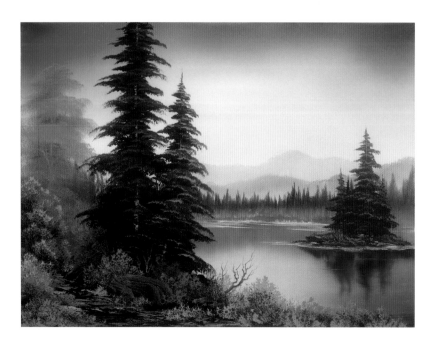

STEP 1 — Load a nice dark paint mixture onto the fan brush. Then, holding the brush vertically, touch the canvas to create the centerline of each tree.

STEP 2 — Use just the corner of the brush to begin adding small top branches.

STEP 3 — Working from side to side, as you move down each tree, apply more pressure to the brush, forcing the bristles to bend downward, and automatically the branches will become larger as you near the base of each tree.

STEP 4 — Add the trunks with a small roll of a mixture of Titanium White and Dark Sienna on the knife.

STEP 5 — Add Cadmium Yellow and Midnight Black to the fan brush and very lightly touch highlights to the branches.

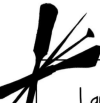

Large Tree Trunks

To paint larger tree trunks, first load dark paint on the fan brush. Starting at the top of the canvas, hold the brush vertically and pull down. Apply more pressure on the brush near the base to thicken the trunk. Highlight the right sides of the trunks with a lighter paint mixture on the long edge of the knife. Add branches using dark paint with thinner on a liner brush.

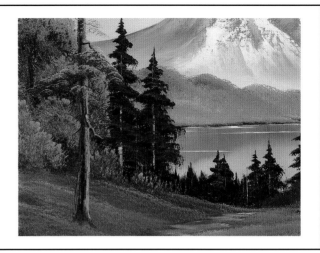

An Impression of Treetops

Load both sides of the 2-inch or 1-inch brush with paint, and then tap downward with one corner of the brush to indicate the distant hills in the background. With very short upward strokes, you can create the impression of tiny treetops along the top edges of the hills. Use a darker paint mixture each time you move forward in the painting.

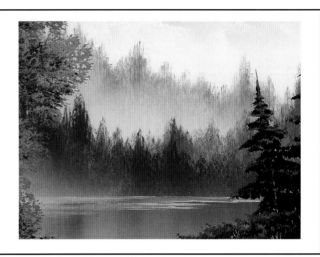

Grassy Areas

Underpaint the land areas with a dark foliage mixture on a 2-inch brush, and then reload it with various mixtures of all the yellows and Bright Red to apply highlights to these areas. Give a slight upward "push" to the brush to create taller patches of grass. Work in layers as you move forward, being careful not to cover all of the dark base color already on the canvas.

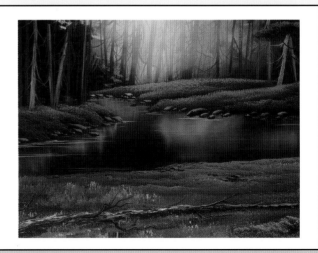

Graceful Mountains

"You have the ability to move mountains," Bob Ross told us. And all you need is some paint, a knife, and a 2-inch brush. When you reach a mountain in one of the projects in this book, refer back to these pages for detailed instructions. Colors vary from painting to painting.

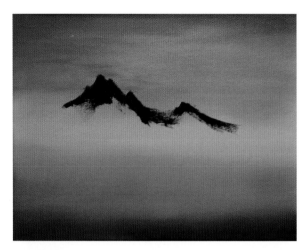

STEP 1 — Use the knife and a mixture of Midnight Black, Prussian Blue, Alizarin Crimson, and Van Dyke Brown to paint the mountain. Pull the mixture out very flat on your palette, hold the knife straight up, and "cut" across the mixture to load the long edge of the blade with a small roll of paint. (Holding the knife straight up will force the small roll of paint to the very edge of the blade.) With firm pressure, shape just the top edge of the mountain.

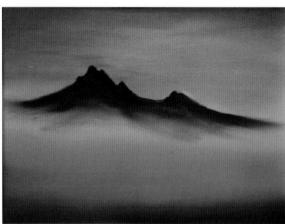

STEP 2 — When you are satisfied with the basic shape of the mountaintop, use the knife to remove any excess paint. Then, with the 2-inch brush, blend the paint down to the base of the mountain.

Mist

Diffuse the base of the hills by firmly tapping with a clean, dry 2-inch brush, creating the illusion of mist. Gently lift upward to blend and soften the mist.

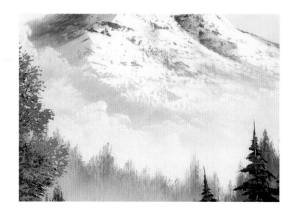

"You have the ability to move mountains."

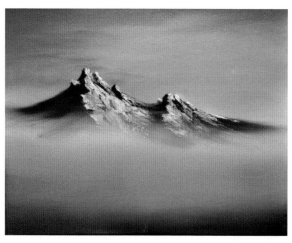

STEP 3 — Highlight the mountain with various mixtures of Titanium White and Midnight Black. Again, load the long edge of the knife blade with a small roll of paint. Starting at the top (and paying close attention to angles), glide the knife down the right side of each peak, using so little pressure that the paint "breaks."

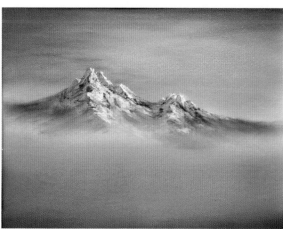

STEP 4 — Use a mixture of Titanium White, Prussian Blue, Midnight Black, Van Dyke Brown, and Alizarin Crimson, applied in the opposite direction, for the shadowed sides of the peaks. Again, use so little pressure that the paint "breaks."

Tap a clean, dry 2-inch brush to diffuse the base of the mountain (carefully following the angles). If desired, gently lift upward to create the illusion of mist.

Clouds

Load a fan brush with Titanium White. With just one corner of the brush, use tiny circular strokes for cloud shapes. Blend the base of the clouds with just the top corner of a clean, dry 2-inch brush. Again use small, circular strokes, and then gently lift upward to "fluff."

GRACEFUL MOUNTAIN

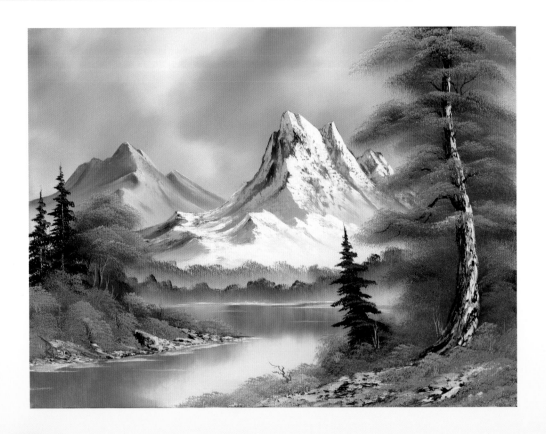

BOB ROSS TOOLS & MATERIALS:

- 1-inch landscape brush
- 2-inch background brush
- #6 fan brush
- #2 script liner brush
- Large knife
- Small knife
- 18″ x 24″ canvas

- Liquid White
- Alizarin Crimson
- Bright Red
- Cadmium Yellow
- Dark Sienna
- Indian Yellow
- Midnight Black

- Phthalo Blue
- Prussian Blue
- Sap Green
- Titanium White
- Van Dyke Brown
- Yellow Ochre

> *"Let's go crazy, what the heck.*
> *Take a 2-inch brush...*
> *This is your bravery test."*

CANVAS PREPARATION

Use the 2-inch brush to cover the entire canvas with a thin, even coat of Liquid White. Don't let the Liquid White dry before you begin.

Sky & Water

STEP 1

With the 2-inch brush and a small amount of Midnight Black and Phthalo Blue, use crisscross strokes to paint the sky. Without cleaning the brush, use these same two colors to add the water with long, horizontal strokes. Leave the center area of the canvas quite light. Use crisscross strokes to blend the sky and long, horizontal strokes to blend the water area.

Mountains

STEP 2

To paint the small, distant mountain, follow the instructions on page 14. For the colors, create a mixture of Prussian Blue, Midnight Black, and Titanium White for the small, distant mountain. Add some of this mixture to a small amount of Titanium White for the highlights.

Use a small amount of this mixture on the left sides of the peaks to indicate shadows.

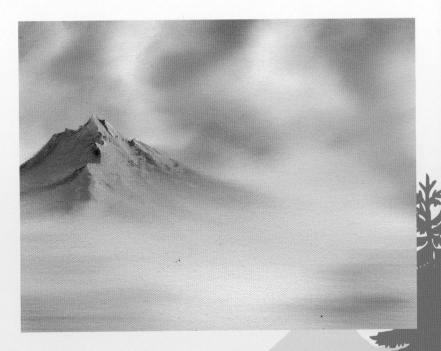

STEP 3

Use the same technique to paint the larger, closer mountain. Create a darker mixture of Midnight Black and Prussian Blue. With the long edge of the knife, shape the mountain.

To highlight the mountain, load the long edge of the knife with a small roll of Titanium White. Then use a mixture of Titanium White and Phthalo Blue to create shadows on the left sides of the peaks.

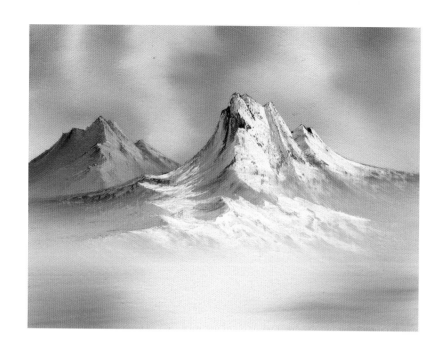

Distant Hills

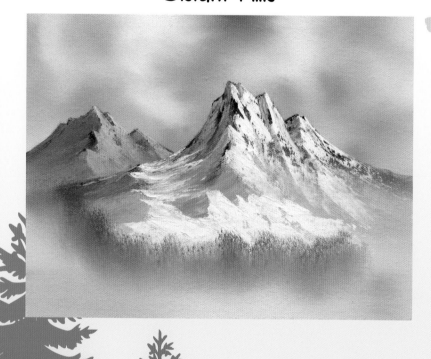

STEP 4

Use the knife to make a mixture of Midnight Black, Prussian Blue, Van Dyke Brown, and Alizarin Crimson on your palette. To a small portion of this mixture, add Titanium White for a lighter value. Load the 1-inch brush with the lighter mixture and use short, downward strokes to create distant tree shapes. Mist the base of these foothills by firmly tapping with a clean, dry 2-inch brush, and then lift upward.

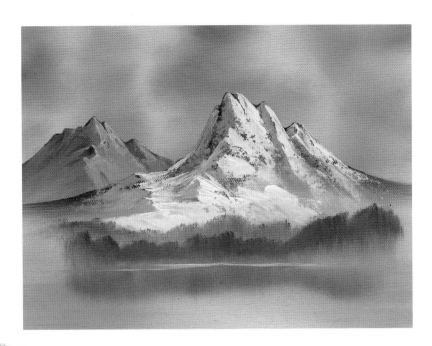

Make the second range of hills with the darker mixture on the 1-inch brush. Again use the 2-inch brush to tap, mist, and lift upward.

Reflect the foothills in the still water using the 1-inch brush with the darker paint mixture. Use the 2-inch brush to pull down the reflections, and then gently brush across. Use a small roll of a mixture of Liquid White and Phthalo Blue on the knife to cut in the water lines.

"You have to have dark in order
to show light, just like in life."

Middleground Trees & Bushes

STEP 6

Underpaint the larger trees and bushes on the left side with a mixture of Midnight Black, Prussian Blue, Van Dyke Brown, and Alizarin Crimson on the 2-inch brush. Just tap downward to block in the basic tree and bush shapes. By starting at the base of the trees, the color will become lighter as you near the treetops. Extend the dark base color into the water for reflections. Pull down and gently brush across to create a watery appearance.

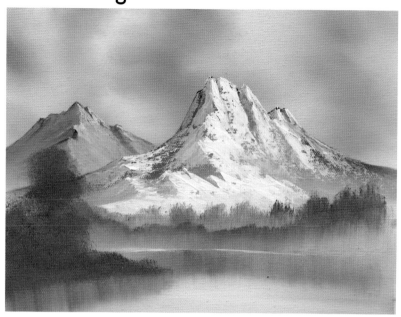

Foreground Trees & Bushes

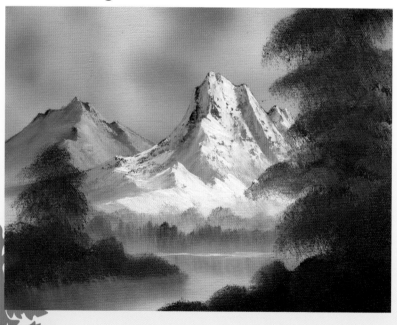

STEP 7

Use the 2-inch brush and the same dark mixture to block in the large foreground trees on the right side of the painting.

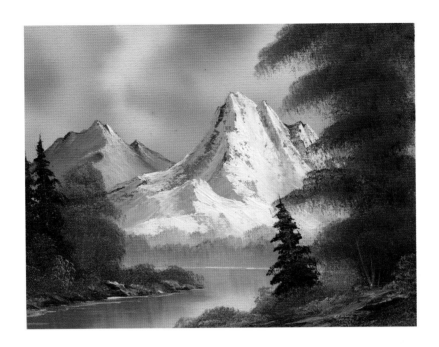

STEP 8

To paint the evergreens, load the fan brush with a dark mixture of Midnight Black, Phthalo Blue, Sap Green, Van Dyke Brown, and Alizarin Crimson. Refer to page 12 for instructions on painting trees.

Create some dark highlights on the trees and bushes by adding Cadmium Yellow and Yellow Ochre to the same brush. Using just one corner of the brush, tap in the leaf patterns to form individual tree and bush shapes.

"This would be a good place for my little squirrel to live."

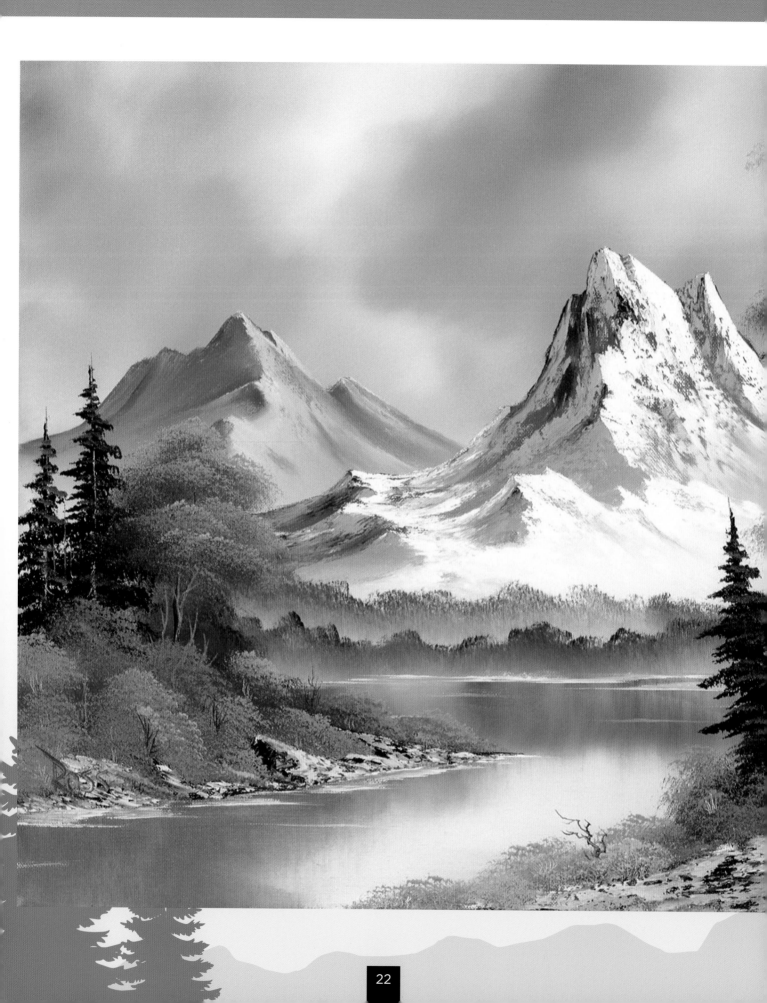

Use Van Dyke Brown on the long edge of the small knife to create the large tree trunk on the right. Highlight the tree trunk using a mixture of Dark Sienna, Phthalo Blue, and Titanium White on the knife. Add branches to the large tree, using thinned Van Dyke Brown on the liner brush.

Create the bright leaf highlights using all the yellows on the 1-inch brush. Add the land areas with Van Dyke Brown on the knife, and then highlight with a mixture of Van Dyke Brown and Titanium White, using so little pressure that the paint "breaks." Add bright highlights on the small trees and bushes by tapping with the 1-inch brush using various mixtures of Sap Green, the yellows, and Bright Red. Without destroying all the dark base color, work in layers, carefully forming each individual tree and bush shape.

Finishing Touches

Use the point of the knife to scratch in the indications of sticks and twigs, or add tiny details with a thin brown mixture on the liner brush. Don't forget to sign your finished masterpiece!

SURF'S UP

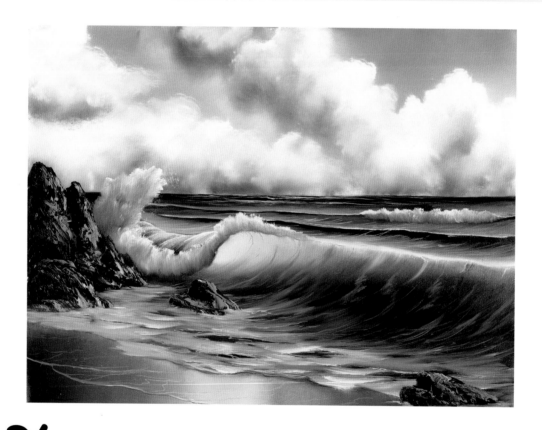

BOB ROSS TOOLS & MATERIALS:

- 2-inch background brush
- #6 fan brush
- #6 bristle filbert brush
- #2 script liner brush
- Large knife
- 18" x 24" canvas
- Masking tape

- Liquid White
- Liquid Clear
- Titanium White
- Bright Red
- Phthalo Blue
- Prussian Blue
- Midnight Black

- Dark Sienna
- Van Dyke Brown
- Alizarin Crimson
- Cadmium Yellow
- Yellow Ochre

"And success with painting leads to success with many things. It carries over into every part of your life."

CANVAS PREPARATION

With a strip of masking tape, mark the horizon about 8 inches down from the top of an 18" x 24" canvas. Cover the area above the horizon with a thin, even coat of Liquid White. Use the 2-inch brush and long, horizontal and vertical strokes for even paint distribution. Apply Liquid Clear below the horizon in the same manner.

Sky

STEP 1

Swirl in dark cloud shapes using a mixture of Midnight Black and Alizarin Crimson on the 2-inch brush.

STEP 2

With a mixture of Phthalo Blue, Titanium White, and just a touch of Bright Red on the 2-inch brush, add the sky color to the area between the clouds. With a clean, dry 2-inch brush, highlight the clouds with a mixture of Titanium White and just a touch of Bright Red using the top corner of the brush and small circular strokes. Don't cover all the dark in your clouds. Use circular motions with just the top corner of a clean, dry 2-inch brush to blend, and then gently lift upward to fluff.

Water

STEP 3

Remove the masking tape to expose a nice, straight horizon line. Use a mixture of paint thinner, Phthalo Blue, and Alizarin Crimson on the filbert brush to roughly sketch in the large wave shape.

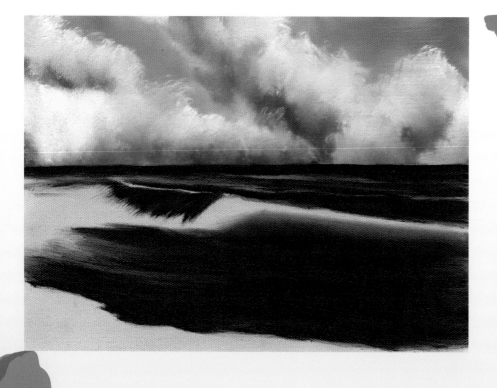

STEP 4

Fill in the entire water area with a mixture of Prussian Blue and Alizarin Crimson loaded on the 2-inch brush. Use long, horizontal strokes. Without cleaning the brush, add a little Yellow Ochre to the mixture as you move forward in the painting.

Still without cleaning the brush, pick up Midnight Black and Yellow Ochre and use long, horizontal strokes to add the shadow area under the large wave, extending the water onto the beach area. Continue by adding Phthalo Blue and Yellow Ochre to the large wave, leaving the very top edge and the transparent "eye" unpainted. With the same brush, pull this dark color over the top of the breaker.

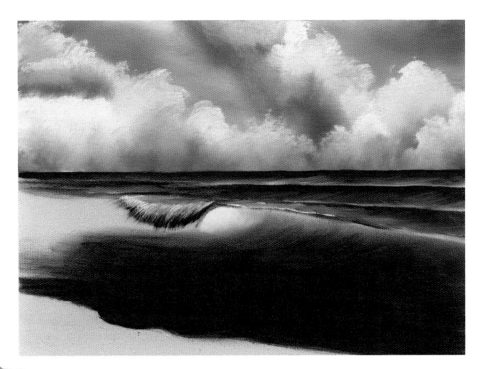

To create the background swells, add two long, horizontal lines using Titanium White on the fan brush. Also add this white to the top edge of the wave and across the top of the breaker. With a clean, dry fan brush, use a small sweeping motion to grab just the top edge of the white lines, pull back, and blend into the dark base color of the water. Leave dark areas between the swells. Then, with Titanium White on the fan brush, touch just a few "sparkles" to the background water near the horizon.

With the knife, make a mixture of Titanium White and a touch of Cadmium Yellow on your palette. Use this mixture on the filbert brush to fill in the transparent "eye" of the wave. Allow this light color to extend out across a small portion of the top of the wave. With the top corner of a clean, dry 2-inch brush, gently blend the "eye" of the wave. Holding the brush horizontally, blend and shape the entire wave, pulling from the light area on top down to the dark base color, being careful not to carry any of the dark colors into the "eye" of the wave. Use a sweeping motion with the brush to create the angle of the water.

Use Titanium White on the fan brush to highlight the top edge of the wave. Still using the fan brush, lightly pull the Titanium White over the top of the breaker to highlight.

"Let's put a few little highlights in here, just to make them little rascals just sparkle in the sun."

STEP 6

Mix a lavender color on the filbert brush with Phthalo Blue, Titanium White, and Alizarin Crimson. Use small, circular strokes to underpaint the foam of the large breaker, and then highlight the top edges with Titanium White and Cadmium Yellow. Lightly blend with a clean, dry filbert brush, and then blend the entire foam area using the top corner of a clean, dry 2-inch brush.

With a mixture of Phthalo Blue, Titanium White, and Alizarin Crimson on the fan brush, form little foam patterns in the large wave. As you move forward, swirl foam into the water by holding the brush horizontally and using Titanium White.

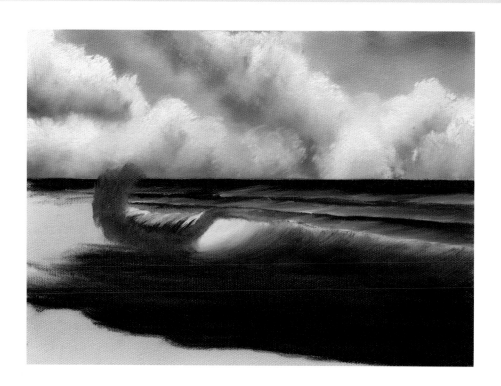

STEP 7

For reflections in the wet sand, use the fan brush and a mixture of Titanium White and Cadmium Yellow, allowing the color to become darker as you move outward by adding Phthalo Blue, Alizarin Crimson, and Midnight Black. Use a clean, dry 2-inch brush to pull down the paint, and then gently brush across for a watery appearance.

Use the liner brush with paint thinner and the white-yellow mixture to highlight the very top edge of the large wave, adding a little Phthalo Blue to the brush as you move outward. Underpaint the foam of the small background breaker using little circles and the lavender mixture on the filbert brush, and then highlight the top edges with the white-yellow mixture. Lightly blend with a clean, dry filbert brush. With the liner brush, add small details and highlights to the water, including a shadow under the water on the beach.

Rocks

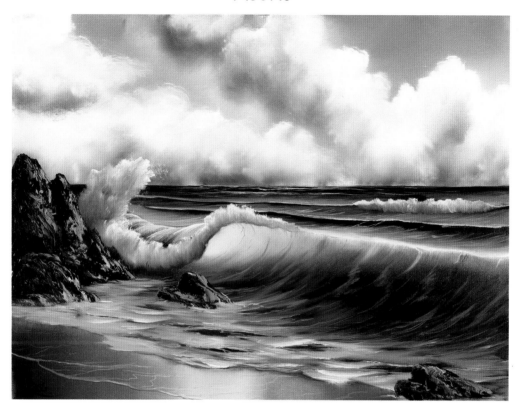

Create the large rock with a mixture of Van Dyke Brown and Dark Sienna on the long edge of the knife, and just slightly push the paint into the canvas. Also add some smaller rocks and stones. Add highlights using a mixture of Titanium White, Dark Sienna, and Yellow Ochre, loaded on the long edge of the knife.

Finishing Touches

Use Titanium White on the fan brush to add water to the base of the rocks and stones and Liquid White on the long edge of the knife to "cut-in" water lines.

Sign your painting, and then stand back to admire your magnificent seascape!

TETON
WINTER

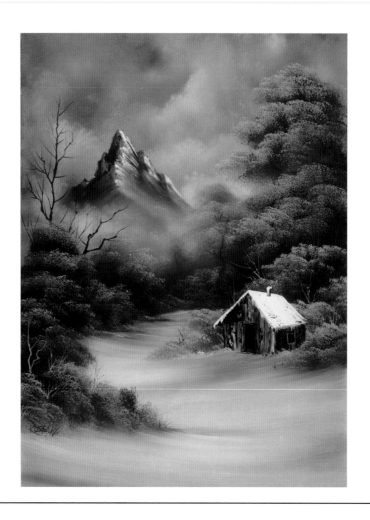

BOB ROSS TOOLS & MATERIALS:

- 1-inch round brush
- 2-inch background brush
- Half-size round brush
- #2 script liner brush
- Large knife
- 18" x 24" canvas

- Black Gesso
- Blue acrylic paint
- Liquid White
- Liquid Clear
- Titanium White
- Phthalo Blue

- Prussian Blue
- Midnight Black
- Alizarin Crimson
- Sap Green

"We just show you how, but you make the decisions. When you have this much power, you have to make big decisions."

CANVAS PREPARATION

Begin by using a crumpled paper towel to randomly daub areas of Black Gesso and blue acrylic paint on the canvas, creating a mottled effect. Be careful not to completely cover the entire canvas with the acrylic colors, allow some areas of the white canvas to remain unpainted. Allow the canvas to dry completely before proceeding.

Sky

STEP 1

When the acrylic paints are dry, use the 2-inch brush to cover the entire canvas with a very small amount of Liquid Clear. Use a paper towel to firmly rub the canvas, removing as much of the Liquid Clear as possible. The remaining Liquid Clear will be sufficient to proceed with the painting. Do not allow the canvas to dry before you begin.

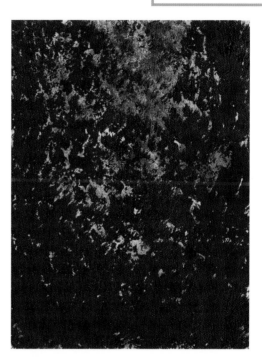

STEP 2

Load the 2-inch brush with Titanium White, tapping the bristles firmly against the palette to ensure an even distribution of paint throughout the bristles. Working in layers, use circular strokes to paint the clouds on the upper portion of the canvas. You can vary the color by adding a small amount of Phthalo Blue to the brush. Notice how the acrylic colors already on the canvas are still slightly visible and create very interesting cloud effects.

Mountain

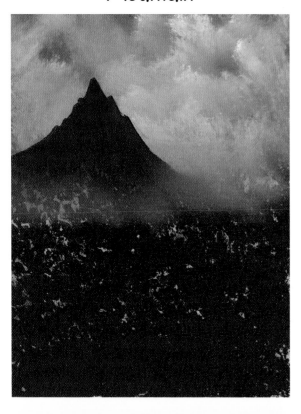

STEP 3

Mix Prussian Blue, Midnight Black, and Alizarin Crimson with the knife. Then follow steps 1 and 2 from page 14 to begin painting the mountain.

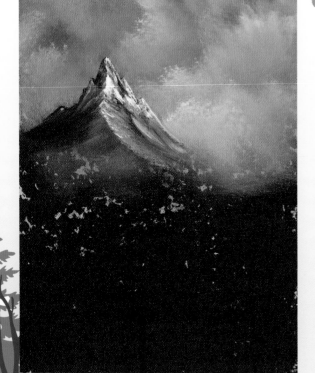

STEP 4

Highlight the mountain with Titanium White, and use a mixture of Titanium White and Phthalo Blue applied in the opposite direction for the shadows. See steps 3 and 4 on page 15 to finish the mountain.

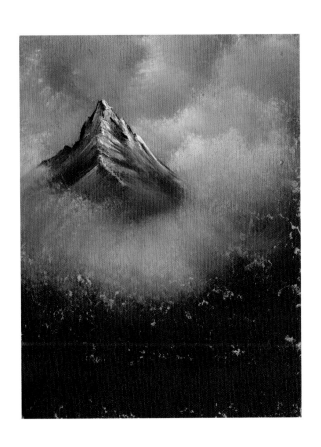

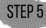
STEP 5

With a mixture of Titanium White and Phthalo Blue on the 2-inch brush, use circular strokes to float a cloud around the base of the mountain.

"Let's make some nice little clouds that just float around and have fun all day."

Background Trees

Tap the bristles of the small round brush into the dark mountain mixture. Tap downward to block in the trees at the base of the mountain. Add the tree trunks with the same dark mixture and the liner brush. (See how to load a liner brush on page 11.) Apply very little pressure to the brush as you shape the trunks. By turning and wiggling the brush, you can give your trunks a gnarled appearance.

To highlight the trees, load the small round brush by first dipping it into Liquid White, and then tapping the bristles into a mixture of Titanium White and Phthalo Blue. Again, just tap downward to apply snowy highlights; this is where you begin to shape individual trees.

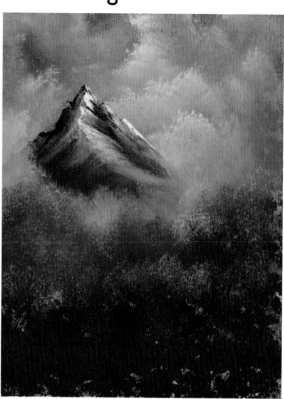

Middleground Trees & Snow

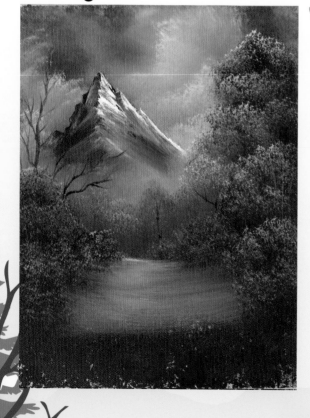

STEP 7

Load the 2-inch brush with Titanium White and use sweeping, horizontal strokes to add the snow to the base of the trees.

Underpaint the larger trees and bushes with the large round brush and the mixture of Prussian Blue, Midnight Black, and Alizarin Crimson. Again, just tap downward. Thin the mixture and use the liner brush to add the trunks and branches.

Highlight the trees with Liquid White, Titanium White, and Phthalo Blue on the small round brush. Carefully shape individual leaf clusters, small bushes, and trees. Then with Titanium White on the 2-inch brush, use horizontal strokes to lay in the snow at the base of the trees.

Cabin

Use the knife to make a brown color on your palette by mixing equal parts of Sap Green and Alizarin Crimson. Clean the knife and use it to remove paint from the canvas in the basic shape of the cabin. Load the long edge of the knife with a small roll of the brown. Paint the back edge of the roof, and then pull down the front and side of the cabin. Use a mixture of brown and Titanium White to highlight the front of the cabin, using so little pressure that the paint "breaks." Use brown on the knife to add the door and the window.

Add the snow-covered roof with Titanium White. Shape the bottom of the cabin by removing the excess paint with a clean knife. Add snow to the base of the cabin with Titanium White on the 2-inch brush, using long, horizontal strokes.

Foreground Trees & Bushes

STEP 9

Use the dark tree mixture on the round brush to add small bushes to the base of the cabin and to underpaint the foreground trees and bushes. Again, highlight with a mixture of Titanium White and Phthalo Blue on the small round brush.

With the 2-inch brush, pull some of the dark tree color from the base of the bushes into the snow for shadows.

Finishing Touches

Use thinned light and dark mixtures on the liner brush to add small sticks and twigs. After you add your signature, your painting is complete!

"These things live right in your brush. All you have to do is shake them out, there."

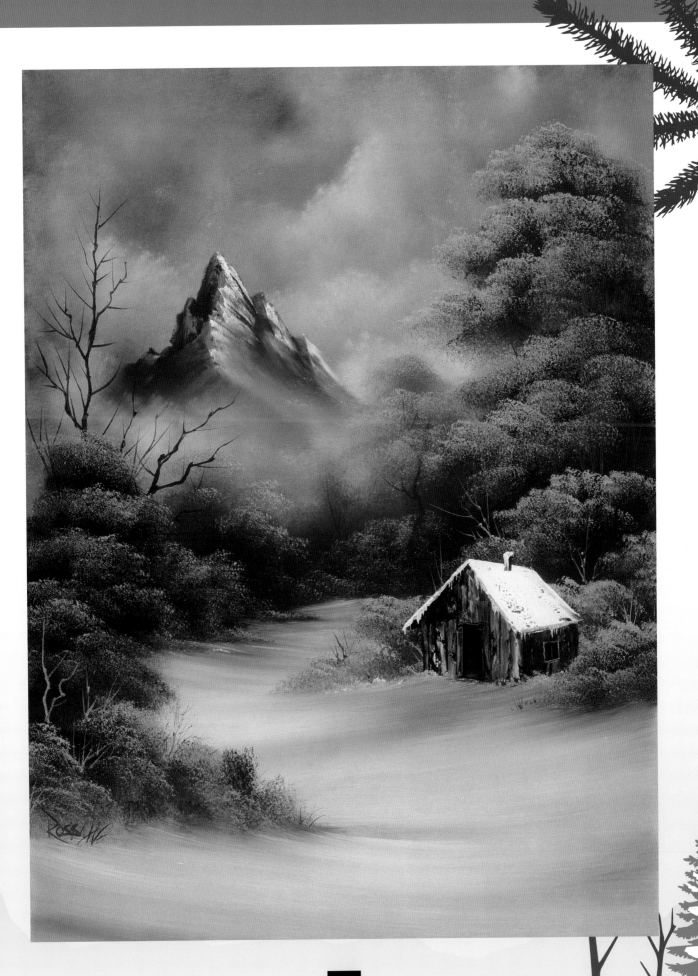

AROUND
THE BEND

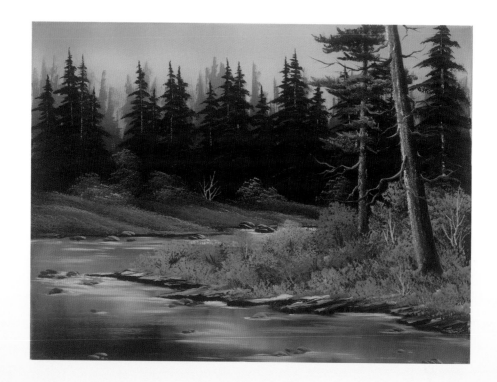

BOB ROSS TOOLS & MATERIALS:

- 1-inch landscape brush
- 2-inch background brush
- #6 bristle filbert brush
- #6 fan brush
- #2 script liner brush
- Large knife
- Foam applicator or old brush
- 18"x 24" canvas

- Black Gesso
- Liquid White
- Liquid Clear
- Titanium White
- Phthalo Green
- Phthalo Blue
- Prussian Blue
- Midnight Black

- Dark Sienna
- Van Dyke Brown
- Alizarin Crimson
- Sap Green
- Cadmium Yellow
- Yellow Ochre
- Indian Yellow
- Bright Red

"Anything we don't like, we'll turn it into a happy little tree or something because, as you know, we don't make mistakes; we just have happy accidents."

CANVAS PREPARATION

Use a foam applicator or old brush to prepaint the dark portions of the painting, including the tiny treetops, with a thin, even coat of Black Gesso. Let it dry completely before proceeding.

STEP 1

When the Black Gesso is dry, use the 2-inch brush to cover the light, upper portion of the canvas with a thin, even coat of Liquid White. Cover the lower portion of the canvas with a very thin coat of Liquid Clear. Before it dries, apply a thin, even coat of a mixture of Sap Green and Van Dyke Brown. Don't let the paint dry before you begin.

Sky

STEP 2

Load the 2-inch brush with a small amount of Phthalo Blue and use crisscross strokes at the top of the canvas to paint the sky. Notice how the color blends with the Liquid White already on the canvas, creating the impression of misty treetops.

Trees

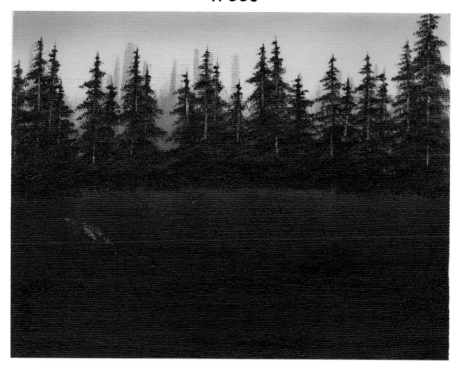

Paint the more distinct evergreens (see page 12 for detailed instructions) with a mixture of Midnight Black, Prussian Blue, Phthalo Green, and Alizarin Crimson. Use a mixture of Titanium White and Dark Sienna for the trunks, and Cadmium Yellow and Midnight Black for the highlights on the branches.

Work in layers while painting the soft grassy area at the base of the trees. Load the 2-inch brush by holding it at a 45-degree angle and tapping the bristles into the various mixtures of all the yellows, Sap Green, Midnight Black, and Bright Red. Allow the brush to "slide" slightly forward in the paint each time you tap. This ensures that the very tips of the bristles are fully loaded with paint. Hold the brush horizontally and gently tap downward.

Water

STEP 5

With Titanium White on the 2-inch brush, create reflections in the water by pulling straight down, and then gently brushing across. Use a small roll of a mixture of Van Dyke Brown and Dark Sienna on the edge of the knife to add the banks along the water's edge. Highlight the banks with a mixture of Titanium White and Van Dyke Brown. Then "swirl" in the water's edge with a mixture of Liquid White and Titanium White on the fan brush.

To add rocks to the water, load the filbert brush with a mixture of Van Dyke Brown and Dark Sienna, and then pull one side of the bristles through a thin mixture of Liquid White, Van Dyke Brown, and Dark Sienna. With the light side of the brush up, use a single, curved stroke to shape each of the rocks. Use the Liquid White and Titanium White mixture on the fan brush to add water ripples to the base of the rocks.

Foreground Land & Plants

STEP 6

Moving forward in the painting, underpaint the small trees and bushes in the foreground with the dark tree mixture on the 1-inch brush. To highlight the trees and bushes, first dip the 1-inch brush into Liquid White. Then pull the brush (several times in one direction to round one corner of the bristles) through various mixtures of the yellows, Bright Red, and Sap Green. With the rounded corner of the brush up, lightly touch the canvas and force the bristles to bend upward to highlight the individual trees and bushes. Concentrate on shape and form—try not to just "hit" at random.

Use a mixture of Van Dyke Brown and Dark Sienna on the knife to add the land at the base of the foreground bushes, and then highlight with a mixture of Titanium White and the browns on the knife.

Again, use Titanium White on the 2-inch brush to pull down the foreground reflections, and then lightly brush across for a "watery" appearance. "Swirl" in the water's edge and ripples with the Liquid White and Titanium White mixture on the fan brush. Then add small rocks and stones to the foreground water with the double-loaded filbert brush.

Large Foreground Trees

STEP 7

Load the fan brush with a mixture of Van Dyke Brown and Dark Sienna. Pull one side of the bristles through the thin mixture of Liquid White and pull the other side through the browns to double-load the brush. Holding the brush vertically, with the light side of the brush on the left, tap downward to paint each of the large evergreen trunks in the foreground.

Use thinned Van Dyke Brown on the liner brush to add small limbs and branches, and then use the dark tree mixture on the fan brush with push-up strokes to add foliage to the large evergreens. Highlight the foliage by adding Cadmium Yellow to the fan brush.

Finishing Touches

Add your signature, and the masterpiece is complete!

LOST LAKE

BOB ROSS TOOLS & MATERIALS:

- 1-inch landscape brush
- 2-inch background brush
- 1-inch oval brush
- #6 fan brush
- #2 script liner brush
- Large knife
- Small knife
- 18″ x 24″ canvas

- Liquid White
- Alizarin Crimson
- Bright Red
- Cadmium Yellow
- Dark Sienna
- Indian Yellow
- Midnight Black
- Sap Green

- Titanium White
- Phthalo Blue
- Prussian Blue
- Van Dyke Brown
- Yellow Ochre

"You really can learn to be creative as you paint. It's like anything else; it just takes a little practice."

CANVAS PREPARATION

Start by covering the entire canvas with a thin, even coat of Liquid White using the 2-inch brush. With long, horizontal and vertical strokes, work back and forth to ensure an even distribution of paint on the canvas. Don't allow the Liquid White to dry before you begin.

Sky

STEP 1

Load the 2-inch brush by tapping the bristles firmly into a very small amount of Alizarin Crimson. Use crisscross strokes to paint a pink glow in the sky, just above the horizon. Without cleaning the brush, add Phthalo Blue to the bristles and, still using crisscross strokes, paint the remainder of the sky. Use the color on the brush to just tap in the indication of small clouds in the pink area of the sky. Blend, using crisscross strokes with a clean, dry 2-inch brush. Underpaint the water with a mixture of Phthalo Blue and Midnight Black on the 2-inch brush using long, horizontal strokes.

Mountains

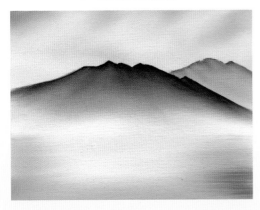

STEP 2

Paint the large mountain with a mixture of Midnight Black, Prussian Blue, Alizarin Crimson, and Van Dyke Brown. See page 14 for instructions on painting mountains. Also tap in the indication of another mountain in the distance.

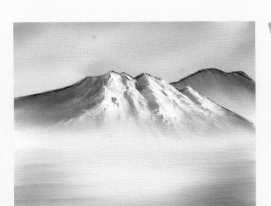

STEP 3

Highlight the mountain with Titanium White blended with a small very small amount of Midnight Black. Add the shadows to the left sides with a mixture of Titanium White, Prussian Blue, and Dark Sienna.

Foothills

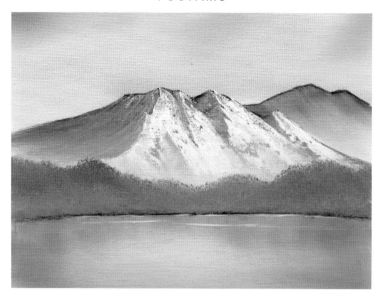

STEP 4

Add Sap Green and Titanium White to the dark mountain mixture. Then use the oval brush to shape the foothills at the base of the mountain. Extend this dark color into the water for reflections. Pull straight down with a clean, dry 2-inch brush and lightly brush across to create the reflections in the water. Add various mixtures of all the yellows to the oval brush and softly highlight the foothills. Use a small roll of Van Dyke Brown on the long edge of the knife to add the banks along the water's edge. Then cut in the water lines and ripples with Liquid White on the edge of the knife.

Evergreen Trees

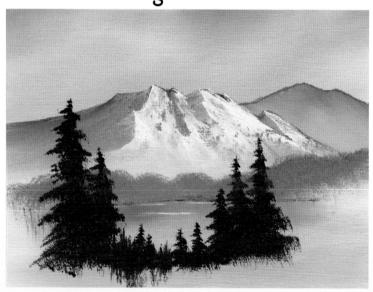

STEP 5

Use the fan brush and a mixture of Midnight Black, Prussian Blue, Van Dyke Brown, Alizarin Crimson, and Sap Green to add the large evergreen trees (see page 12 for instructions). You can make the indication of very small trees by holding the brush vertically and just tapping downward.

"Son of a gun, that's a pretty nice tree for being done that quick."

STEP 6

Load the 2-inch brush with the same dark mixture to underpaint the leafy trees and bushes. Then underpaint the entire lower portion of the canvas with this dark base color. Don't clean your 2-inch brush yet; you'll use it in the next step.

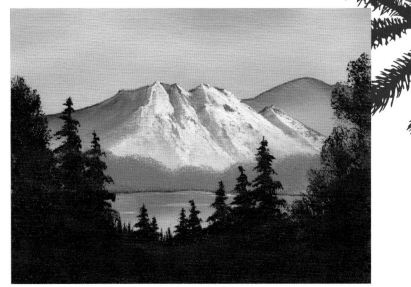

Foreground Trees & Path

STEP 7

(See next page for image) Use a mixture of Dark Sienna and Titanium White on the small knife to add the trunks to the evergreens; indicate trunks, sticks, and twigs by just scratching with the point of the knife.

Dip the 1-inch brush into Liquid White and pull it in one direction (to round one corner) through various mixtures of the dark base color, all the yellows, and Bright Red. With the rounded corner up, force the bristles to bend upward and lightly shape the individual trees and bushes.

Tap the 2-inch brush (which still has the dark mixture on it) into various mixtures of all the yellows and highlight the ground by holding the brush horizontally and tapping downward. Work in layers as you move forward, being careful not to cover all of the dark base color already on the canvas. **(Continued on next page)**

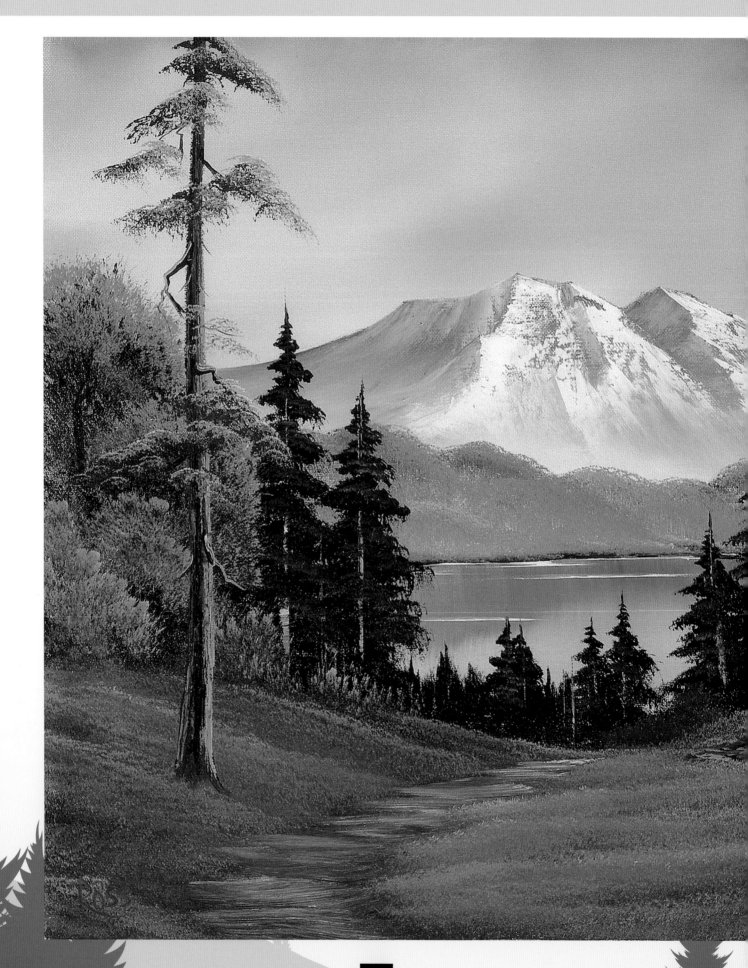

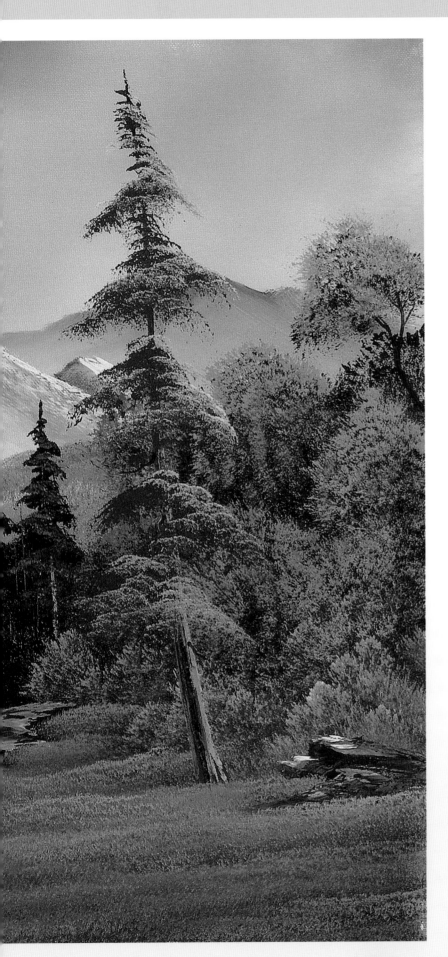

(Continued from page 47)

Use Van Dyke Brown on the fan brush and short, horizontal strokes to add the path, and then highlight with Titanium White. Next, shape small rocks and stones using Van Dyke Brown on the knife, and then highlight with a mixture of Dark Sienna and Titanium White. Use the point of the knife to scratch in small sticks and twigs.

The large tree trunks are made with Van Dyke Brown on the fan brush. Starting at the top of the canvas, hold the brush vertically and just pull down. Apply more pressure on the brush near the base to thicken the trunks. Highlight the right sides of the trunks with a mixture of Dark Sienna and Titanium White on the long edge of the knife.

With a mixture of paint thinner and Van Dyke Brown on the liner brush, add the limbs and branches. Use the dark tree mixture on the oval brush to underpaint the leaf clusters on the trees, and then highlight with various mixtures of all the yellows on the oval brush.

Finishing Touches

Use a thinned paint on the liner brush to sign your new masterpiece!

LAKESIDE
PATH

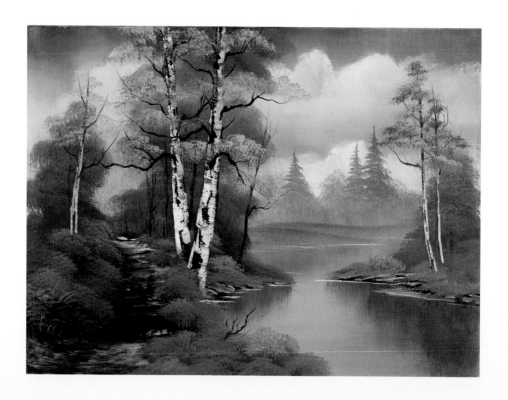

BOB ROSS TOOLS & MATERIALS:

- 2-inch background brush
- #6 fan brush
- #2 script liner brush
- Large knife
- 18" x 24" canvas
- Liquid White
- Titanium White

- Phthalo Blue
- Prussian Blue
- Midnight Black
- Dark Sienna
- Van Dyke Brown
- Alizarin Crimson
- Sap Green

- Cadmium Yellow
- Yellow Ochre
- Indian Yellow
- Bright Red

"This is not something you should labor over or worry about. Enjoy it. If painting does nothing else, it should make you happy."

CANVAS PREPARATION

Start by covering the entire canvas with a thin, even coat of Liquid White using the 2-inch brush. With long horizontal and vertical strokes, work back and forth to ensure an even distribution of paint on the canvas. Don't allow the Liquid White to dry before you begin.

Sky

STEP 1

Load the 2-inch brush with a mixture of Phthalo Blue, Midnight Black, and a touch of Yellow Ochre, tapping the bristles firmly against the palette to evenly distribute the paint. Use small crisscross strokes to paint the sky, leaving some areas open and unpainted for the later addition of clouds. With long, horizontal strokes, add this color to the bottom of the canvas to underpaint the water. Lightly blend the entire canvas with a clean, dry 2-inch brush.

STEP 2

Load a 2-inch brush with Titanium White, and then use circular strokes to add cloud shapes to the unpainted areas of the sky. Use just the top corner of a clean, dry 2-inch brush to blend the bottoms of the clouds and then lightly lift upward to "fluff."

Background & Foreground Trees

STEP 3

Load the fan brush with a mixture of Prussian Blue, Midnight Black, Van Dyke Brown, Yellow Ochre, and Titanium White. Then follow the steps on page 12 to make the small evergreens in the background.

Using the 2-inch brush, add a little Van Dyke Brown to the tree mixture. Hold the brush horizontally and tap in the ground area at the base of the evergreen trees. Pull a little of this color straight down into the water and gently brush across for reflections. With Liquid White loaded on the long edge of the knife, use firm pressure to cut in the water lines.

Add Van Dyke Brown, Dark Sienna, Alizarin Crimson, and Midnight Black to the 2-inch brush. Moving forward in the painting, hold the brush horizontally and tap downward to block in the basic shape of the larger trees and bushes. Reverse the brush and reflect this base color into the water under the land projections; pull down and brush across to create the illusion of water.

STEP 4

Use Van Dyke Brown on the 2-inch brush and sweeping horizontal strokes to underpaint the path on the left side of the painting. Then add the small tree trunks and branches using thinned Van Dyke Brown on the liner brush.

Highlight the trees and bushes by loading the 2-inch brush with various mixtures of all the yellows, Sap Green, and Bright Red. Use just one corner of the brush and tap downward. Try not to just hit at random; this is where you form the individual tree and bush shapes.

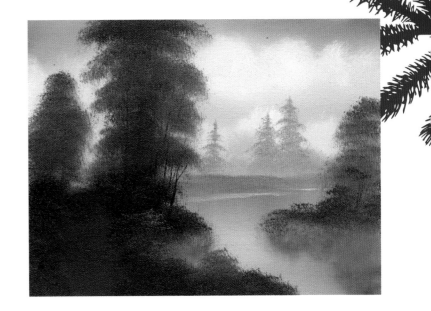

STEP 5

Use Van Dyke Brown on the knife to add the banks along the water's edge. Highlight the banks with a mixture of Titanium White, Dark Sienna, and Phthalo Blue. Apply using so little pressure that the paint "breaks." Load the long edge of the knife with a small roll of Liquid White. Using firm pressure, push the knife straight into the canvas to add the water lines.

Extend grassy areas onto the banks by loading the fan brush with the highlight mixtures of all the yellows, Sap Green, and Bright Red. Hold the brush horizontally and force the bristles to bend upward as you touch the canvas.

Make the bare center tree with the fan brush and a mixture of Prussian Blue, Midnight Black, and Sap Green. Use the point of the knife to just scratch in the indication of a tree trunk.

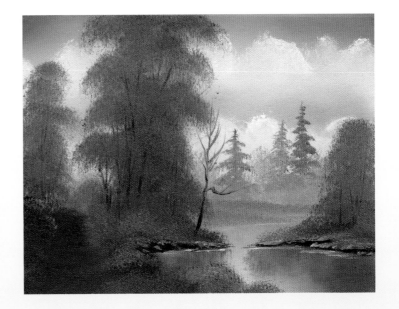

Birch Trees

STEP 6

Start each tree trunk with Van Dyke Brown on the fan brush. Holding the brush vertically, start at the top of the trunk and pull down, using more pressure as you near the base. Highlight the trunks by loading the long edge of the knife with a small roll of Titanium White. Holding the knife blade vertically, just touch the edges of the trunks and pull slightly; try not to cover all of the dark base color.

Add the branches with thinned Van Dyke Brown on the liner brush. Add the leaves with the corner of the 2-inch brush and Cadmium Yellow. Form leaf clusters; don't just hit at random.

"You can move mountains, rivers, trees. You can determine what your world is like."

Path

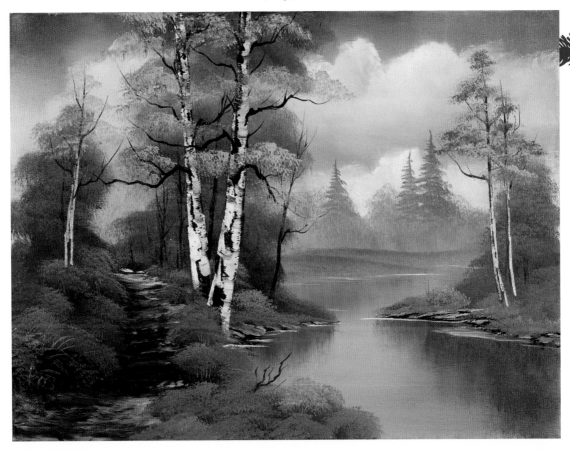

STEP 7

You already underpainted the path. Now highlight it with various mixtures of Dark Sienna and Titanium White using the knife and horizontal strokes, again with so little pressure that the paint "breaks." With a clean, dry fan brush, use gentle, sweeping, horizontal strokes over the highlights to softly blend. Working forward in layers, using the 2-inch brush to extend the grassy areas over the edges of the path.

Finishing Touches

Use thinned Titanium White on the liner brush to add long grasses and other final details to the foreground. Then sign your painting, stand back, and admire!

OVAL
ESSENCE

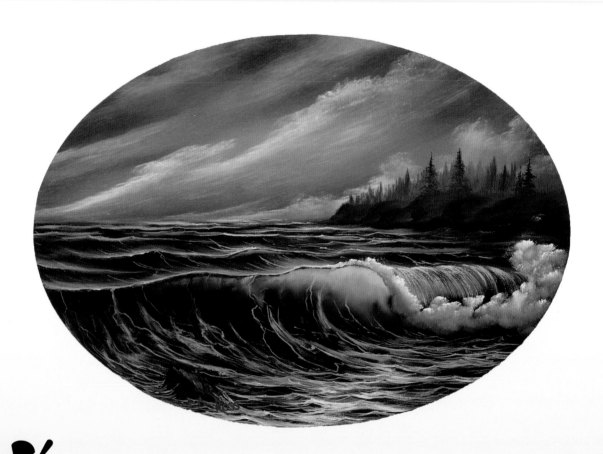

BOB ROSS TOOLS & MATERIALS:

- 1-inch landscape brush
- 2-inch background brush
- #6 fan brush
- #6 bristle filbert brush
- #2 script liner brush
- Small knife
- Foam applicator or old brush

- 18" x 24" canvas
- Adhesive-backed plastic
- Masking tape
- Black Gesso
- Liquid Clear
- Alizarin Crimson
- Cadmium Yellow

- Dark Sienna
- Midnight Black
- Phthalo Blue
- Phthalo Green
- Titanium White
- Van Dyke Brown

> "Anything that you try and you don't succeed... if you learn from it, it's not a failure."

CANVAS PREPARATION

Start by covering the entire canvas with adhesive-backed plastic (such as Con-Tact Brand® paper) from which you have removed a 14" x 20" center oval.

STEP 1

Cover the entire canvas with a thin, even coat of Black Gesso using a foam applicator or old brush and allow it to dry completely before you begin painting. Apply masking tape (just above center) across the horizontal canvas to mark the horizon.

Next use the 2-inch brush to cover the entire canvas with a very small amount of Liquid Clear. Use a paper towel to firmly rub the canvas, removing as much of the Liquid Clear as possible. The remaining Liquid Clear will be sufficient to proceed with the painting. Do not allow the canvas to dry before you begin.

Sky

STEP 2

Load the 1-inch brush with Titanium White and just touch, tap, and rub to add the cloud shapes to the sky. The brush picks up the wet color already on the canvas, automatically adding color to the clouds. Use a clean, dry 2-inch brush to blend the base of the clouds, being careful not to destroy the top edges of the cloud shapes. Use Titanium White on the fan brush to add additional clouds, and then use sweeping, upward strokes to blend the entire sky. Remove the masking tape from the canvas.

Background Land & Water

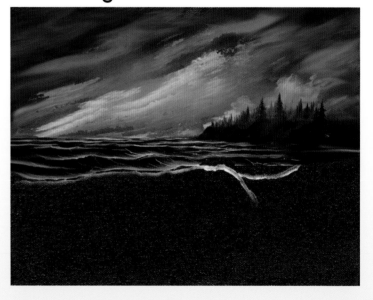

STEP 3

Use the 2-inch brush to add a mixture of Phthalo Blue and Midnight Black along the horizon (the area left dry by the masking tape). Use Titanium White on the filbert brush to lightly sketch the large foreground wave.

Load the fan brush with a mixture of Midnight Black, Phthalo Blue, Phthalo Green, and Van Dyke Brown. Hold the brush vertically and tap downward to indicate the trees in the background, just above the horizon. Use the corner of the brush to add a few branches to the more distinct trees. Shape the rocky land projection under the trees using the same dark mixture on the brush, and then highlight with a very small amount of Titanium White.

With Titanium White on a clean fan brush, use short, rocking strokes to add the water along the horizon and at the base of the land projection. Use long, horizontal strokes to paint the tops of the background swells. With short, sweeping strokes, pull back to blend the tops of the swells. Be very careful not to "kill" all the dark undercolor that separates these background waves.

Large Wave

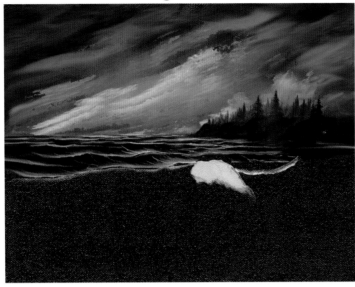

Load the filbert brush with a mixture of Titanium White and a very small amount of Cadmium Yellow. Use circular strokes to scrub the color into the "eye" of the wave. Allow the color to extend out across the top of the wave and gradually fade away into the dark base color already on the canvas. You can repeat this procedure until you achieve the desired amount of brightness, but always start with a clean filbert brush.

"Look around. Look at what we have. Beauty is everywhere—you only have to look to see it."

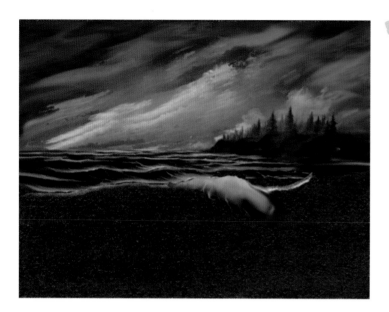

STEP 5

Use the top corner of a very clean, dry 2-inch brush and small circular strokes to lightly blend the "eye" of the wave. Holding the brush horizontally and paying close attention to the angle of the water, use downward strokes to begin shaping the remainder of the wave.

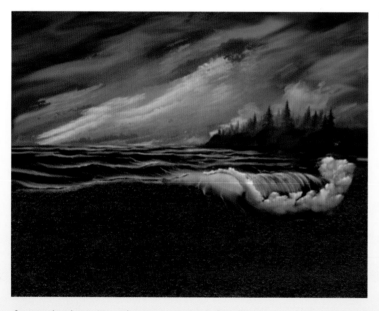

STEP 6

With a clean fan brush and Titanium White, use single downward strokes to highlight the water rolling over the top of the wave.

Underpaint the foam with a lavender mixture of Titanium White, Phthalo Blue, and Alizarin Crimson. Use the filbert brush and small, circular strokes to form the basic shape of the foam at the base and along the edge of the wave.

Highlight the foam with Titanium White on a clean, dry filbert brush. Use tiny, circular, push-up strokes. Add highlights to the top edges of the foam where the light would strike; don't completely cover the foam shadow. Use the top corner of a clean, dry 2-inch brush and small circular strokes to lightly blend the base of the highlights. Try not to touch the top edges of the foam, as the highlights should remain quite bright, but a few touches above the foam with the corner of the brush will create the illusion of foam spray. Use a thinned, dark blue mixture on the liner brush to add a tiny shadow under the foam along the edge of the wave.

Foreground Water

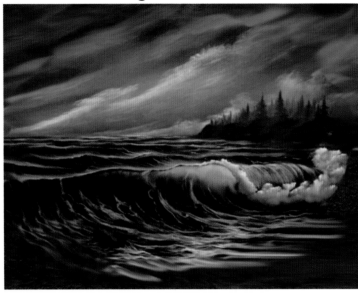

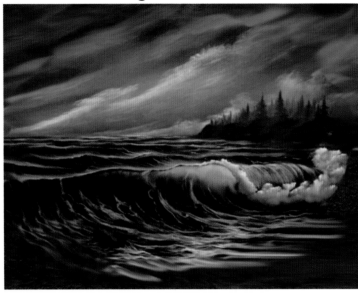

STEP 7

Load a clean fan brush with Titanium White. Paying close attention to the angle of the water, use short, horizontal and vertical scrubbing strokes to create the foam patterns in the wave and highlight the water in front of the large wave. Again, be very careful not to "kill" all of the dark base color. You can very lightly blend these highlights with a clean, dry 2-inch brush.

Use paint thinner and various mixtures of Titanium White, Phthalo Blue, and Cadmium Yellow on the liner brush to add final "sparkles" to the water, paying close attention to where the light would strike.

The stone in the foreground is made with the small knife using a mixture of Van Dyke Brown and Dark Sienna. Highlight the top of the stone with a mixture of Dark Sienna and Titanium White, using so little pressure on the knife that the paint "breaks."

Finishing Touches

The final touch in this painting is to remove the contact paper from the canvas, and voilà, you have created a masterpiece— a masterpiece you should not forget to sign!

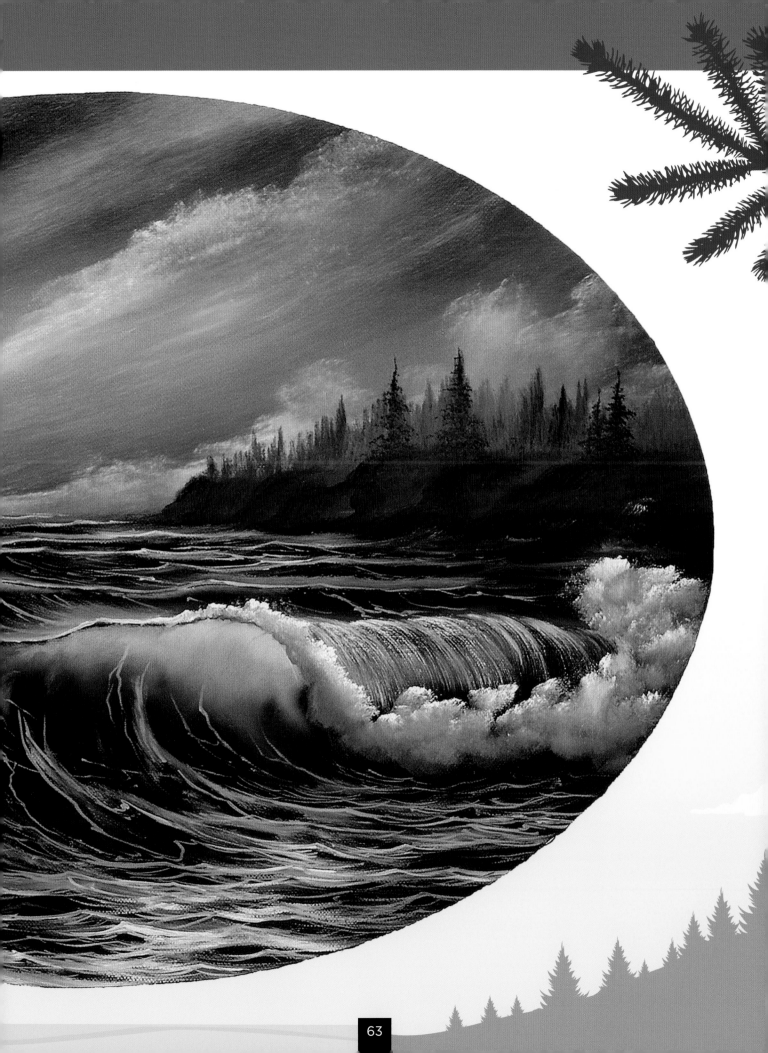

GRAY
MOUNTAIN

BOB ROSS TOOLS & MATERIALS:

- 1-inch landscape brush
- 2-inch background brush
- #6 fan brush
- #2 script liner brush
- Large knife
- 18" x 24" canvas
- Liquid White

- Dark Sienna
- Van Dyke Brown
- Alizarin Crimson
- Sap Green
- Cadmium Yellow
- Yellow Ochre
- Indian Yellow

- Bright Red
- Titanium White
- Phthalo Green
- Phthalo Blue
- Prussian Blue
- Midnight Black

"In painting, you have unlimited power. You have the ability to move mountains. You can bend rivers."

CANVAS PREPARATION

Begin by using the 2-inch brush to cover the entire canvas with a thin, even coat of Liquid White. With long horizontal and vertical strokes, work back and forth to ensure an even distribution of paint on the canvas. Don't allow the Liquid White to dry before you begin.

Sky

STEP 1

Load the 2-inch brush with a small amount of Indian Yellow and begin by creating the golden glow in the sky with crisscross strokes across the canvas, just above the horizon. Then use Indian Yellow and horizontal strokes to reflect the glow into the water, just below the horizon.

Without cleaning the brush, reload it with Yellow Ochre and continue working upward in the sky with crisscross strokes. Again, reflect the Yellow Ochre in the water with horizontal strokes.

Still without cleaning the brush, reload it with a very small amount of Bright Red and continue with crisscross strokes near the top of the sky and horizontal strokes near the bottom of the canvas.

STEP 2

Reload the 2-inch brush with a mixture of Alizarin Crimson and Phthalo Blue and use crisscross strokes across the top of the sky. Hold the brush horizontally and just tap downward to indicate the cloud shapes.

Use the mixture of Alizarin Crimson, Phthalo Blue, and long, horizontal strokes across the bottom of the canvas to complete the water. With a clean, dry 2-inch brush, blend the entire canvas with long, horizontal strokes.

Mountain

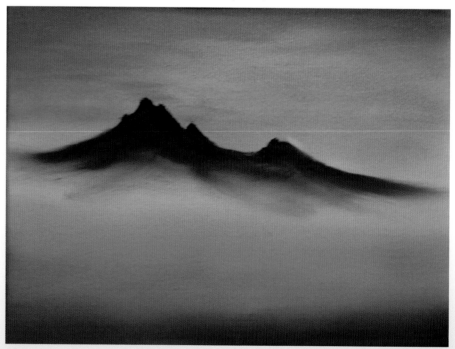

STEP 3

Use the knife and a mixture of Midnight Black, Prussian Blue, Alizarin Crimson, and Van Dyke Brown to paint the large mountain. Follow the steps on page 14 for painting the mountain.

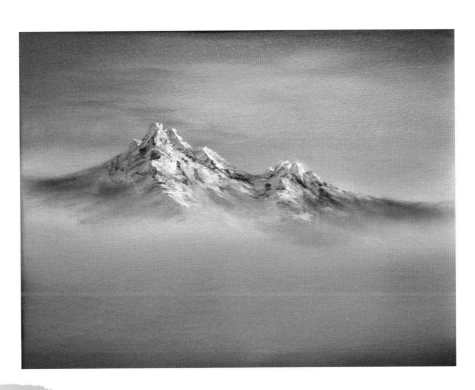

STEP 4

Highlight the mountain with various mixtures of Titanium White and Midnight Black. Use a mixture of Titanium White, Prussian Blue, Midnight Black, Van Dyke Brown, and Alizarin Crimson, applied in the opposite direction, for the shadowed sides of the peaks.

"Every day is a good day when you paint."

STEP 5

To create depth in your painting, use the same mixtures to add the smaller mountains at the base of the large mountain.

Foothills

STEP 6

Load the 2-inch brush with a mixture of Titanium White and the mountain color. Hold the brush horizontally and tap downward to paint the first range of foothills at the base of the mountains. Still holding the brush horizontally, make short upward strokes to indicate tiny treetops.

Hold the brush flat against the canvas at the base of the foothills and pull the color straight down to reflect the hills into the water, and then lightly brush across.

Make several ranges of hills, each one getting progressively darker as you work forward in the painting.

STEP 7

Without cleaning your brush, add a small amount of a mixture of Sap Green and Cadmium Yellow to the brush and lightly tap to highlight the closer hills.

Then add water lines and ripples with the knife and a mixture of Liquid White with a small amount of Bright Red.

Middleground Evergreens

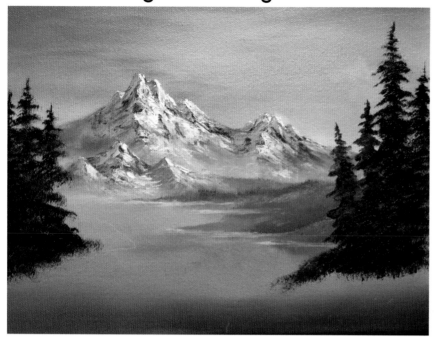

STEP 8

Load the fan brush to a chiseled edge with a very dark mixture of Midnight Black, Prussian Blue, Phthalo Green, and Alizarin Crimson. Then use the technique found on page 12 to paint the trees.

Foreground Trees & Bushes

STEP 9

Underpaint the small trees and bushes at the base of the evergreens with the same dark mixture on the 1-inch brush, extending the color into the water for reflections. Use the 2-inch brush to pull the reflections straight down, and then lightly brush across.

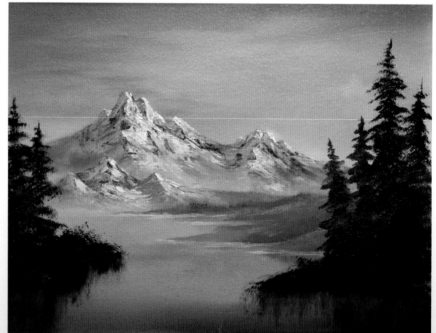

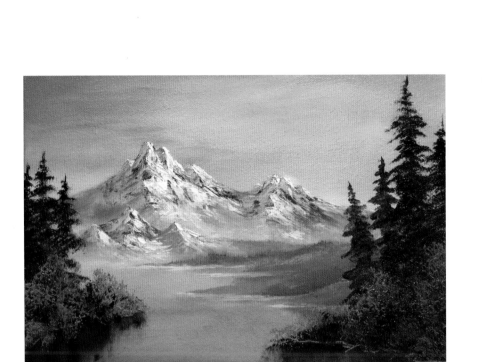

STEP 10

To highlight the trees and bushes, first dip the 1-inch brush into Liquid White. Then, with the handle straight up, pull the brush (several times in one direction to round one corner of the bristles) through various mixtures of Sap Green, all the yellows, and Bright Red. With the rounded corner of the brush up, force the bristles to bend upward to highlight the individual trees and bushes. Concentrate on shape and form.

"We artists are a different breed of people. We're a happy bunch."

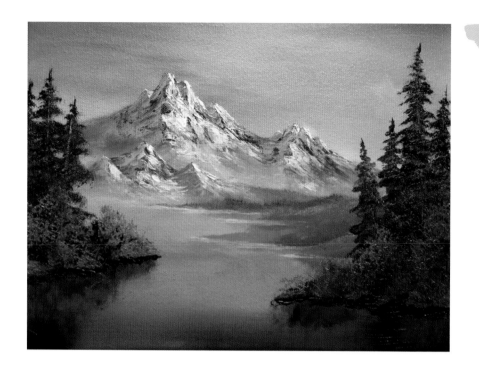

STEP 11

Reverse the brush to reflect the highlights into the water. Use the 2-inch brush to first very lightly pull the reflections down, and then brush across to give the reflections a "watery" appearance.

Add the evergreen trunks with a small roll of a mixture of Titanium White and Dark Sienna on the knife. Use the fan brush to very lightly touch highlights to the right side of the branches.

STEP 12

Use Van Dyke Brown on the knife to add the land area at the base of the foreground trees, with close attention to angles. Highlight the land with a mixture of Van Dyke Brown and Titanium White on the knife, using so little pressure that the paint "breaks."

With a small roll of Liquid White on the edge of the knife, cut in foreground water lines and ripples. And to complete your painting, use the point of the knife to scratch in the indication of tiny trunks, sticks, and twigs.

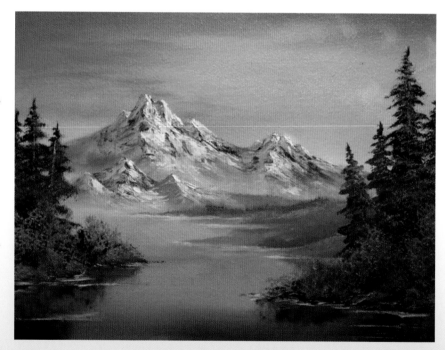

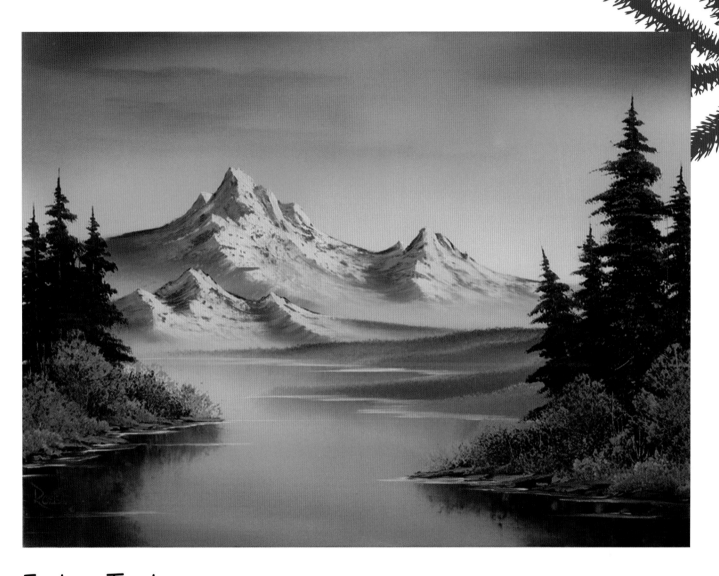

Finishing Touches

Load the liner brush with thinned color of your choice and sign your painting!

NATURE'S SPLENDOR

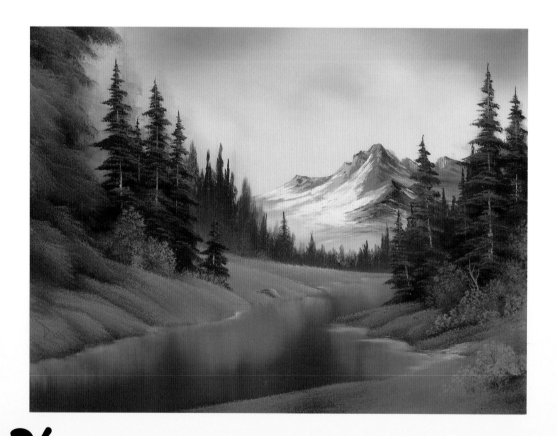

BOB ROSS TOOLS & MATERIALS:

- 1-inch landscape brush
- 2-inch background brush
- #6 bristle filbert brush
- #6 fan brush
- #2 script liner brush
- Large knife
- Foam applicator or old brush
- 18" x 24" canvas

- Black Gesso
- Liquid White
- Liquid Clear
- Titanium White
- Phthalo Blue
- Prussian Blue
- Midnight Black
- Dark Sienna

- Van Dyke Brown
- Alizarin Crimson
- Sap Green
- Cadmium Yellow
- Yellow Ochre
- Indian Yellow
- Bright Red

"Talent is a pursued interest. Anything that you're willing to practice, you can do it."

STEP 1

Use the 2-inch brush to cover the dry, Black Gesso with a very thin coat of Liquid Clear. While the Liquid Clear is still wet, use a mixture of Alizarin Crimson and Phthalo Blue on the 2-inch brush to overpaint the entire Black Gesso area. Cover the unpainted sky area with a thin, even coat of Liquid White. Move on to the next step without allowing these paints to dry.

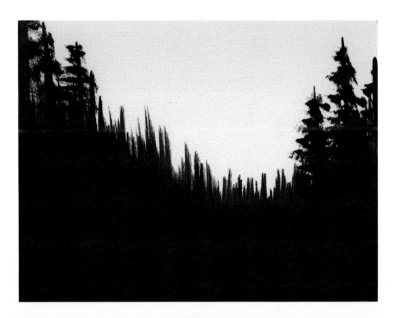

Sky

STEP 2

Load the 2-inch brush with a small amount of Phthalo Blue, tapping the bristles firmly against the palette to ensure an even distribution of paint throughout the bristles. Starting at the top of the canvas and working downward, use crisscross strokes to begin painting the sky. As you work downward, change to a Lavender color by using a mixture of Alizarin Crimson and Phthalo Blue on the 2-inch brush. Clean the brush and use a mixture of Titanium White and Yellow Ochre just above the horizon. With a clean, dry 2-inch brush, blend the entire sky.

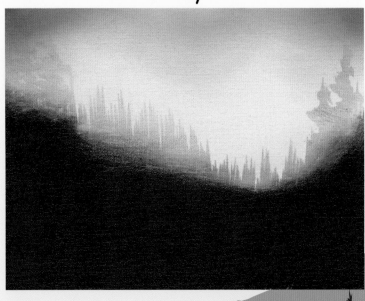

Mountain

STEP 3

Follow the steps on page 14 to paint the mountain. The mountain is made with the knife and a mixture of Midnight Black, Alizarin Crimson, and Prussian Blue. Use a mixture of Titanium White, Alizarin Crimson, and Phthalo Blue on the knife to apply the shadows to the right sides of the peaks. Apply a mixture of Titanium White, Dark Sienna, Yellow Ochre, and Bright Red to the left sides of the peaks, and then highlight with Titanium White.

Background Trees

STEP 4

Use the knife to make a dark mixture on your palette of Prussian Blue, Midnight Black, Van Dyke Brown, Sap Green, and Alizarin Crimson. To a small amount of this dark mixture, add some Yellow Ochre and Titanium White, for a lighter value. Make the indication of trees by holding the brush vertically and just tapping downward. Then use the 2-inch brush with a very, very small amount of Titanium White to tap the base of the trees, creating the illusion of mist.

Use mixtures of all the yellows, Sap Green, and Bright Red on the 2-inch brush to highlight the grassy area at the base of the trees. Load the brush by holding it at a 45-degree angle and tapping (allowing the brush to slide slightly forward with each tap) into the various paint mixtures. Hold the brush horizontally and gently tap downward.

STEP 5

To begin adding the water, use Titanium White on the 2-inch brush and pull straight down; then lightly brush across. Highlight the foreground grassy area.

Load the fan brush to a chiseled edge with the original dark mixture of Prussian Blue, Midnight Black, Van Dyke Brown, Sap Green, and Alizarin Crimson. Then paint the large evergreen trees using the technique on page 12. Add the trunks with a small roll of a mixture of Titanium White and Dark Sienna on the knife. Use the fan brush to very lightly touch highlights to the branches with a mixture of the dark tree color and the yellows.

Water & Evergreens

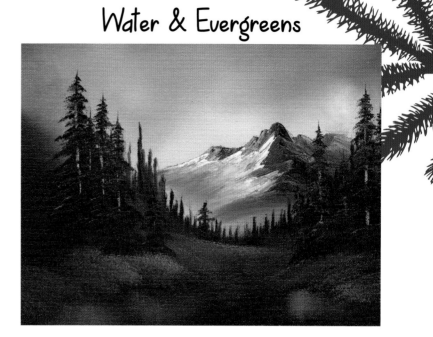

Small Leaf Trees & Bushes

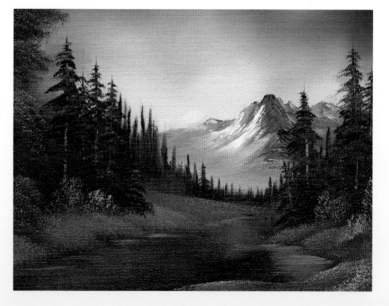

STEP 6

Use various mixtures of Liquid White, Sap Green, all the yellows, and Bright Red for the small trees and bushes at the base of the evergreens. Pull the 1-inch brush through the mixtures in one direction to round one corner. With the rounded corner up, touch the canvas and force the bristles to bend upward as you create individual tree and bush shapes.

STEP 7

Use a mixture of Titanium White and Dark Sienna on the knife to cut in the water lines and ripples.

Load the filbert brush with Van Dyke Brown, and then pull one side of the bristles through a mixture of Liquid White, Yellow Ochre, and Dark Sienna. With a single stroke, you can add the stone and its highlights to the water's edge.

Add the final bit of land in the foreground, still tapping downward with the 2-inch brush and the yellow highlight colors. Then use the dark tree mixture on the 2-inch brush to underpaint the large leaf tree on the left side of the painting. Add Cadmium Yellow to the same brush to highlight the leaf clusters.

Finishing Touches

Sign your painting with pride. Hopefully, with this masterpiece, you have truly experienced the joy of painting!

"Isn't that fantastic? I knew you could do it."

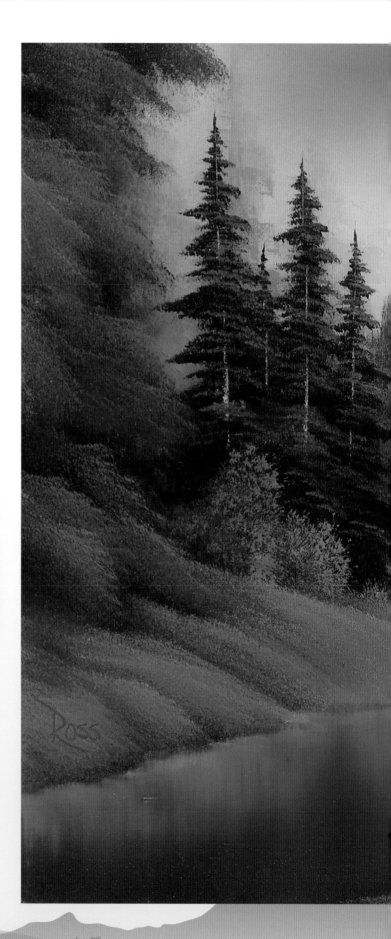

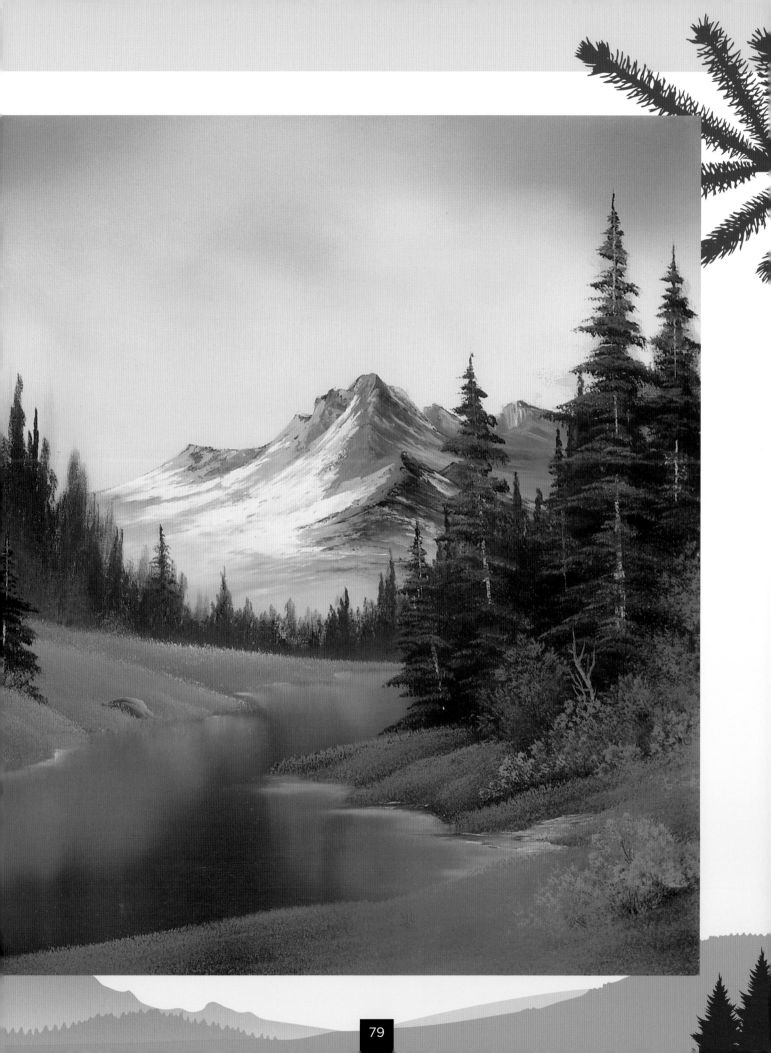

THROUGH
THE WINDOW

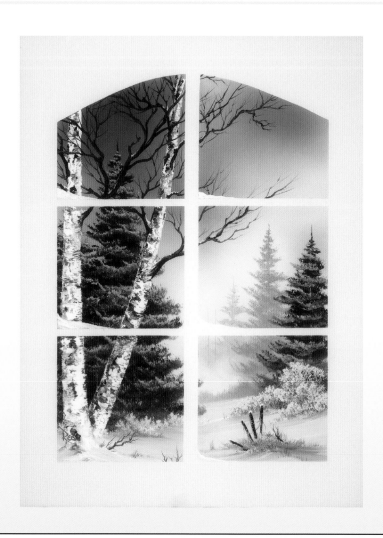

BOB ROSS TOOLS & MATERIALS:

- 1-inch landscape brush
- 2-inch background brush
- #3 fan brush
- #2 script liner brush
- Large knife
- Adhesive-backed plastic

- Masking tape
- 18"x 24" canvas
- Liquid White
- Titanium White
- Phthalo Blue
- Prussian Blue

- Midnight Black
- Dark Sienna
- Van Dyke Brown
- Alizarin Crimson

"The secret to doing anything is believing that you can do it."

CANVAS PREPARATION
Start by covering the entire canvas with a piece of adhesive-backed plastic (such as contact paper) from which you have removed a center piece in the shape of the window. Use strips of masking tape to mask off the window panes.

Sky

STEP 1

Begin by using the 2-inch brush to cover the entire canvas with a thin, even coat of Liquid White. With long horizontal and vertical strokes, work back and forth to ensure an even distribution of paint on the canvas. Don't allow the Liquid White to dry before you begin.

Use the 2-inch brush with a small amount of a mixture of Midnight Black and Prussian Blue. Starting at the top of the canvas, working down toward the horizon, paint the sky with crisscross strokes. Allow some areas in the sky to remain quite light.

With a small amount of Titanium White on the 2-inch brush, use crisscross strokes to brighten the light areas in the sky.

Background Evergreens

STEP 2

Load the small fan brush to a chiseled edge with a light blue mixture of Midnight Black, Prussian Blue, and Titanium White. (Be sure that the mixture is slightly darker than the color of the sky.) Then use the technique on page 12 to paint the trees.

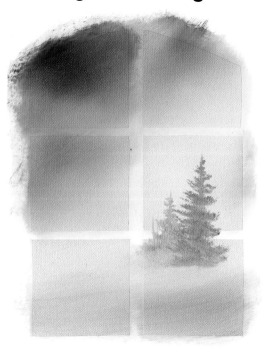

STEP 3

Continue using the light blue tree mixture on the fan brush to tap in the shapes of small bushes at the base of the distant evergreens. Then use the blade of the knife to cut in the indication of the tree trunks.

Load both sides of a clean, dry 2-inch brush with Titanium White and, holding the brush horizontally, use sweeping, horizontal strokes to lay in the snow at the base of the background trees.

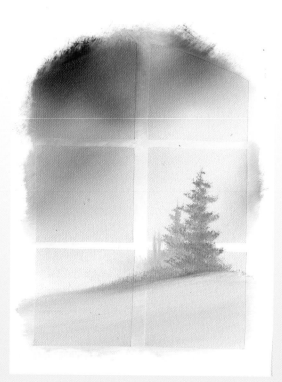

Middleground Evergreens

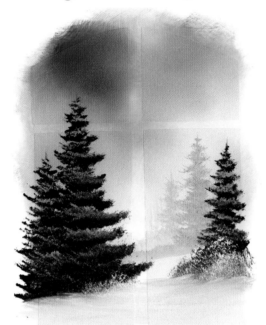

Use the knife to make a darker tree mixture consisting of Midnight Black, Prussian Blue, and Alizarin Crimson. Load the fan brush with this dark tree color and, moving forward in the painting, add the larger evergreens. Touch highlights to the trees with a mixture of Liquid White, Titanium White, and Phthalo Blue on the fan brush.

Use the dark tree color on the 1-inch brush to underpaint the small trees and bushes at the base of the evergreens. To highlight the bushes, first dip the 1-inch brush into Liquid White. Then, with the handle straight up, pull the brush (several times in one direction to round one corner of the bristles) through Titanium White. With the rounded corner of the brush up, force the bristles to bend upward to apply highlights to the individual trees and bushes. Concentrate on shape and form—not just "hitting" at random.

Load the 2-inch brush with Titanium White and extend the snow from the base of the small trees and bushes in toward the foreground of the painting. By allowing the bristles to pick up some of the dark tree color already on the canvas, you create the shadows in the snow.

Foreground Trees & Bushes

STEP 5

To paint the large birch trees in the foreground, first load the long edge of the knife with a mixture of Midnight Black and small amounts of Van Dyke Brown and Prussian Blue. Working upward from the base of each tree, use short, horizontal strokes to shape the large trunks. Reload the knife with Titanium White and use short, curved strokes to add highlights to the trunks, allowing some of the dark undercolor to remain visible.

Add the smaller limbs and branches using a black-brown mixture and the liner brush. (Learn how to load a liner brush on page 11.) Apply very little pressure to the brush as you shape the limbs and branches. Turn and wiggle the brush to give your branches a gnarled appearance. Use Liquid White on the liner brush to add snowy highlights to some of the limbs and branches.

Lay in the snow at the base of the birch trees with Liquid White and Titanium White on the fan brush. Without cleaning the brush, reload it with a very small amount of the dark tree mixture to add the indication of small patches of grass at the base of the birch trees.

Fence

STEP 6

To paint the fence, load the knife with a mixture of Van Dyke Brown and Dark Sienna. Holding the knife vertically, just touch the canvas to indicate each fence post. Add the highlights with brown and white on the knife.

Tap in the bushes at the base of the fence with the dark tree color on the 1-inch brush, and then highlight with a thin blue and white mixture.

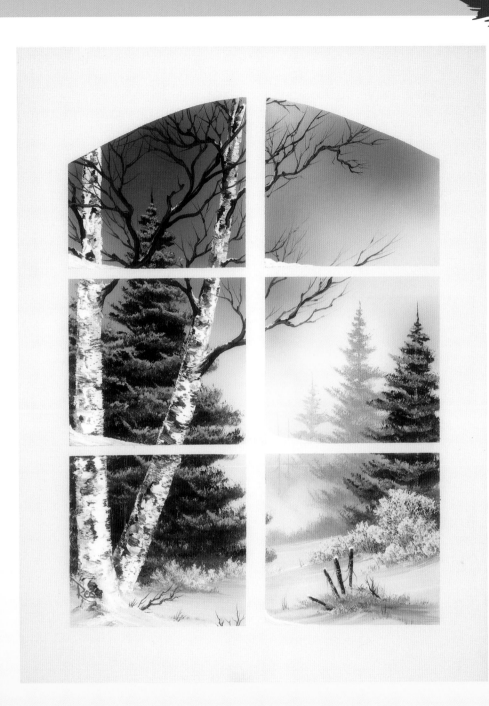

Finishing Touches

Use a mixture of Liquid White and Titanium White on the fan brush to add snow to the window panes. Hold the brush horizontally and just pull across the top edge of each pane.

Add small sticks and twigs to the foreground with a thin mixture of Midnight Black and Van Dyke Brown on the liner brush to complete the painting.

Carefully remove the masking tape and contact paper to reveal your finished masterpiece. Don't forget to add your signature!

WINTER'S PEACE

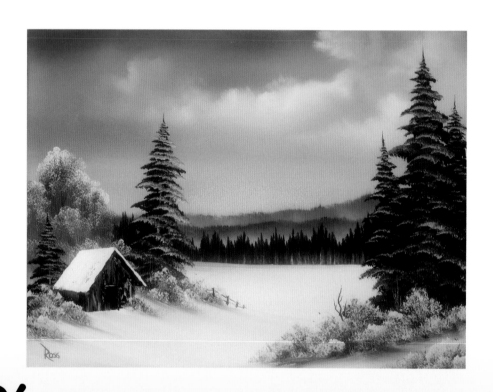

BOB ROSS TOOLS & MATERIALS:

- 1-inch landscape brush
- 2-inch background brush
- #6 fan brush
- #2 script liner brush
- Large knife
- 18" x 24" canvas

- Liquid White
- Titanium White
- Phthalo Blue
- Prussian Blue
- Midnight Black
- Dark Sienna

- Van Dyke Brown
- Alizarin Crimson
- Yellow Ochre
- Indian Yellow
- Bright Red

"Let's build a happy little cloud... Let's build some happy little trees."

CANVAS PREPARATION

Use the 2-inch brush to cover the entire canvas with a thin, even coat of Liquid White. Don't let the Liquid White dry before you begin.

Sky

STEP 1

Load the 2-inch brush with a small amount of Indian Yellow and begin painting the golden glow in the sky with crisscross strokes across the canvas, just above the horizon. Reload the brush with Yellow Ochre and continue working upward in the sky with crisscross strokes. Use a very small amount of Bright Red and continue with crisscross strokes near the top of the sky.

Clean and dry the 2-inch brush and reload it with a small amount of Phthalo Blue, and use crisscross strokes across the top of the canvas to complete the sky. With Phthalo Blue still on the 2-inch brush, underpaint the lower portion of the canvas with long, horizontal strokes.

Load the fan brush with Titanium White and use small, circular strokes to "swirl-in" the cloud shapes in the sky. Use a clean, dry 2-inch brush and circular strokes to blend out the bottom edge of the clouds, and then use sweeping, upward strokes to "fluff." Repeat these same basic steps to add another layer of clouds in the sky.

Background Hills & Trees

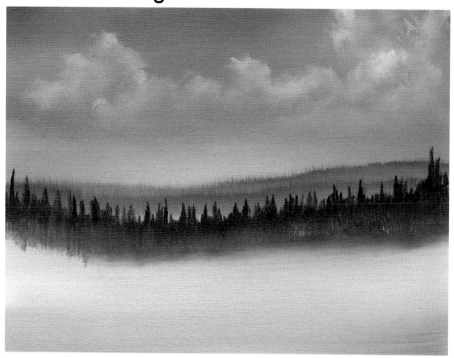

STEP 2

Use the knife to make a mixture of Midnight Black, Prussian Blue, Alizarin Crimson, and Titanium White. Load both sides of the 2-inch brush and tap downward with one corner of the brush to indicate the distant hills. With very short upward strokes, create the impression of tiny treetops along the top edges of the hills. Diffuse the base of the hills by firmly tapping with a clean, dry 2-inch brush, creating the illusion of mist. Gently lift upward to blend and soften the mist. Add a closer range of background hills, using a slightly darker mixture (less Titanium White).

With a mixture of Midnight Black, Prussian Blue, and Alizarin Crimson on the fan brush, tap downward to indicate the tiny evergreens in the background. Use a clean, dry 2-inch brush and upward strokes to blend the base of the trees. Then, with Titanium White on the 2-inch brush, use sweeping horizontal strokes to add the snow at the base of the background trees, carefully creating the lay of the land.

"Did you ever think you could just take a great big old brush and make all these beautiful little trees? You really can."

Middleground Trees & Bushes

STEP 3

Use a mixture of Van Dyke Brown and Dark Sienna on the 2-inch brush to tap in the undercolor of the leafy trees. Highlight these trees with a mixture of Titanium White and a very small amount of Bright Red on the 2-inch brush. Use the point of the knife to scratch in the indication of tree trunks. Create the evergreen trees (see page 12 for the painting technique) with a mixture of Prussian Blue, Midnight Black, Alizarin Crimson, and Van Dyke Brown on the fan brush. Lightly touch highlights to the branches with a mixture of Liquid White, Titanium White, and Phthalo Blue on the fan brush.

Load the 1-inch brush with a mixture of Phthalo Blue and the dark evergreen color and underpaint the bushes at the base of these trees. To highlight, first dip the 1-inch brush into Liquid White. Then, with the handle straight up, pull the brush (several times in one direction to round one corner of the bristles) through a mixture of Titanium White and Phthalo Blue. Touch just the rounded corner of the brush into a very thin mixture of Liquid White and Bright Red. (By loading the brush in this manner, you can apply two highlight colors at once.) With the rounded corner of the brush up, force the bristles to bend upward to highlight the individual trees and bushes.

Use Titanium White on the 2-inch brush and sweeping horizontal strokes to extend the snow to the foreground of the painting.

Cabin

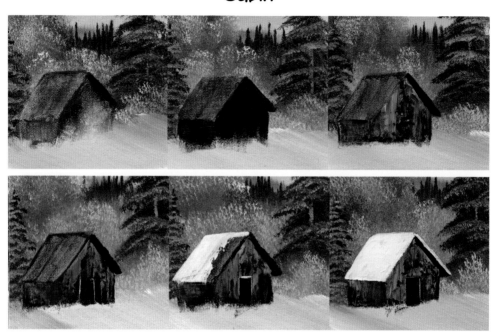

STEP 4

Use a clean knife to remove paint from the canvas in the basic shape of the cabin. Load the knife with a mixture of Van Dyke Brown and Dark Sienna. Touch in the back eaves of the roof, and then pull down the front and side of the cabin. Use a marbled mixture of Titanium White and the browns on the knife to highlight the front of the cabin, using so little pressure that the paint "breaks." Use pure Van Dyke Brown to highlight the darker side of the cabin, and then add the door.

Pull down the front of the roof with thick Titanium White. Don't forget to highlight the back eaves. With white still on the knife, cut in the outline of the door. Remove any excess paint from the base of the cabin with a clean knife.

Foreground Trees

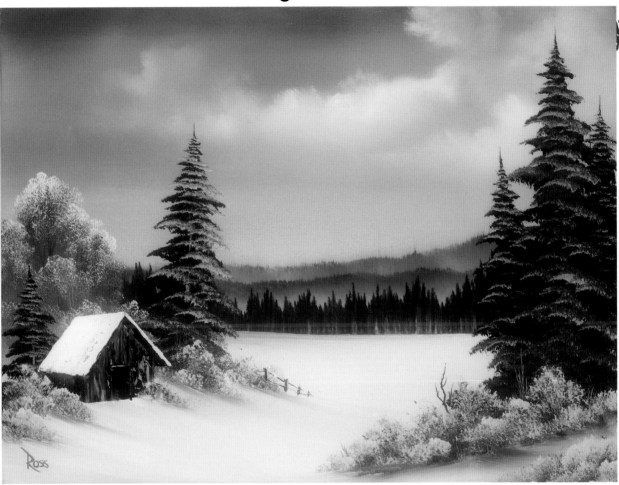

STEP 5

Paint the large evergreens in the foreground with the original, dark evergreen color on the fan brush. Cut in trunks, branches, sticks, and twigs with the knife. Then underpaint the bushes around the cabin and foreground bushes with the evergreen color on the 1-inch brush.

Use a mixture of Liquid White and Phthalo Blue on the fan brush to highlight the evergreens. Load the 1-inch brush with a mixture of Liquid White, Titanium White, Phthalo Blue, and Bright Red to add snowy highlights to the foreground bushes.

Finishing Touches

Lay in the last snowy areas with Titanium White on the 2-inch brush, and then add the fence with thinned brown on the liner brush, and your painting is complete!

DISTANT
MOUNTAINS

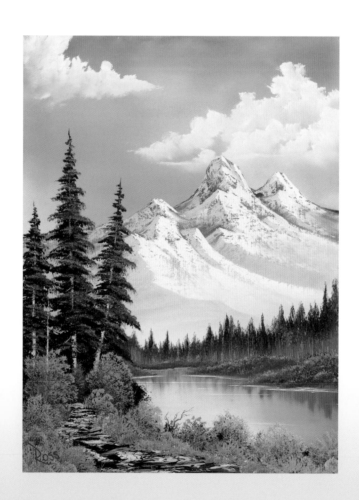

BOB ROSS TOOLS & MATERIALS:

- 1-inch landscape brush
- 2-inch background brush
- #6 fan brush
- #2 script liner brush
- Large knife
- 18" x 24" canvas
- Liquid White

- Alizarin Crimson
- Bright Red
- Cadmium Yellow
- Dark Sienna
- Indian Yellow
- Midnight Black
- Phthalo Blue

- Phthalo Green
- Prussian Blue
- Sap Green
- Titanium White
- Van Dyke Brown
- Yellow Ochre

> *"You have unlimited power here. You can do that. You can do anything on this canvas, anything."*

CANVAS PREPARATION

Start by covering the entire canvas with a thin, even coat of Liquid White, using the 2-inch brush. Use long horizontal and vertical strokes to ensure an even distribution of paint on the canvas. Don't let the Liquid White dry before you begin.

Sky & Water

STEP 1

Load the 2-inch brush with a small amount of Phthalo Blue, tapping the bristles firmly against the palette to ensure an even distribution of paint. Use crisscross strokes to apply the color to the sky. By starting at the top of the canvas, the color will automatically become lighter as you work down toward the horizon. Without cleaning the brush, pick up a little more Phthalo Blue and a very small amount of Phthalo Green. Use long, horizontal strokes to add the water, holding the brush flat and pulling from the outside edges of the canvas in toward the center.

Allow the center of the canvas to remain light to create the illusion of shimmering light across the water. Use a clean, dry 2-inch brush to blend the entire canvas.

STEP 2

Load the fan brush with Titanium White. With just one corner of the brush, use tiny circular strokes to form the cloud shapes. Blend the base of the clouds with just the top corner of a clean, dry 2-inch brush. Again, use small, circular strokes, and then gently lift upward to "fluff."

Mountain

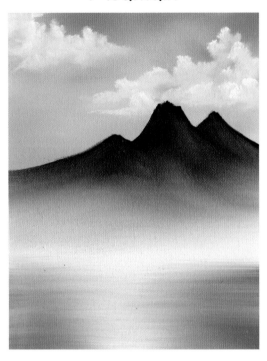

STEP 3

Make the mountains with a mixture of Prussian Blue, Midnight Black, Van Dyke Brown, and Alizarin Crimson. See page 14 for the technique for painting mountains.

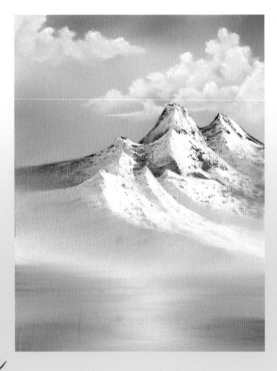

STEP 4

Use Titanium White to highlight the mountain. The shadows on the left sides of the peaks are a mixture of Titanium White and Phthalo Blue.

STEP 5

Load the fan brush with the mountain mixture and a small amount of Sap Green. Hold the brush vertically and tap downward to indicate the small evergreens at the base of the mountain. Extend this dark color into the water for reflections. With a clean, dry 2-inch brush, gently pull down the reflections, then brush across—giving the appearance of water.

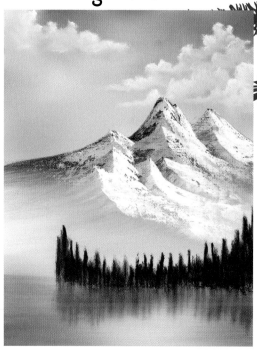

STEP 6

Use various mixtures of all the yellows and Sap Green on the fan brush to create the grassy areas at the base of the small trees.

Pull some Liquid White out flat on your palette and cut across to load the long edge of the knife. Push the knife straight into the canvas and use firm pressure to cut in the water lines and ripples. Make sure the lines are horizontal to the top and bottom of the canvas.

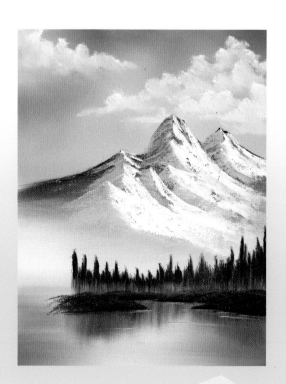

Large Evergreen Trees

STEP 7

Use a mixture of Prussian Blue, Midnight Black, Van Dyke Brown, and Alizarin Crimson to paint the evergreens (see page 12 for the technique).

Underpaint the bushes with the same dark mixture you used for the large evergreens. Use the 2-inch brush to just block in the basic bush shapes in the foreground.

STEP 8

(See opposite page) Touch a few highlights to the large evergreen branches using a mixture of Sap Green and Cadmium Yellow, still keeping these trees quite dark for contrast.

For the bushes, highlight with various mixtures of all the yellows, Sap Green, and Bright Red. Dip the 1-inch brush into Liquid White, then pull the brush in one direction through the various mixtures to round one corner. With the rounded corner up, shape the bushes by gently touching the canvas forcing the bristles to bend upward.

To make the path, load the knife with a small roll of Van Dyke Brown and use short, horizontal strokes to shape the path. Watch your perspective; the path should get wider as it comes forward in the painting. Highlights are the same horizontal strokes, using a mixture of Dark Sienna, Phthalo Blue, and Titanium White. Use so little pressure on the knife that the paint "breaks."

Finishing Touches

Add small bushes and grasses over the edges of the path, and then use the point of the knife to scratch in additional sticks and twigs. You can also add final details (small tree trunks, etc.) with the liner brush. For details on loading a liner brush, see page 11. Add the final details, especially your signature!

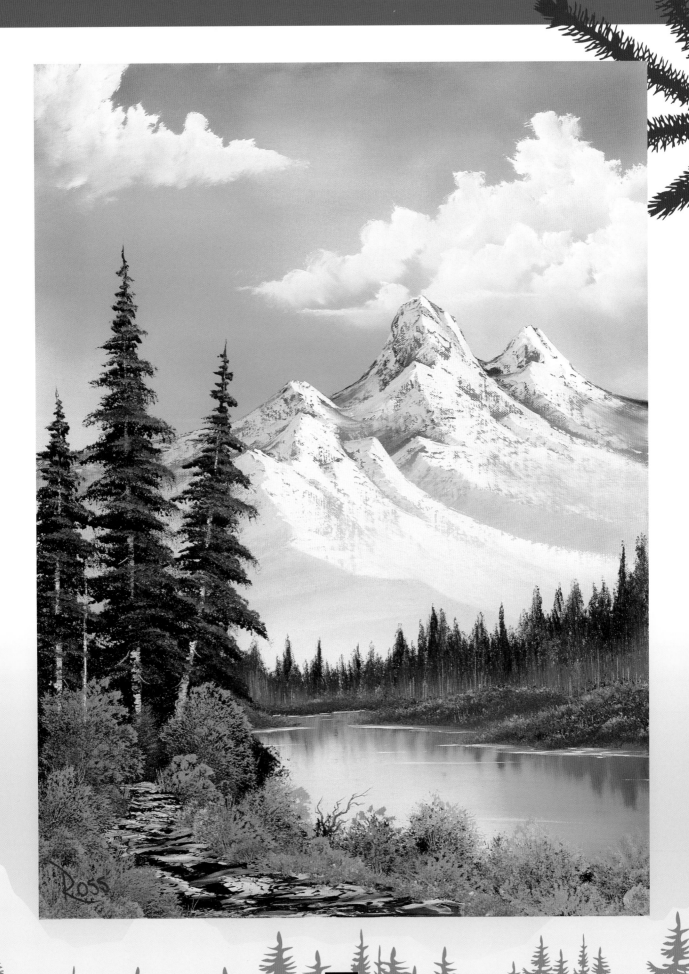

MYSTIC MOUNTAIN

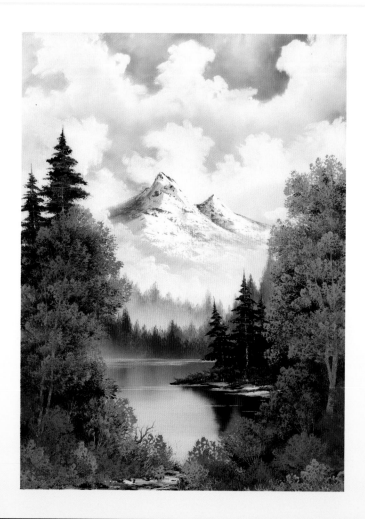

BOB ROSS TOOLS & MATERIALS:

- 1-inch landscape brush
- 2-inch background brush
- #6 fan brush
- #2 script liner brush
- Large knife
- 18" x 24" canvas
- Liquid White

- Titanium White
- Phthalo Blue
- Prussian Blue
- Midnight Black
- Dark Sienna
- Van Dyke Brown
- Alizarin Crimson

- Sap Green
- Cadmium Yellow
- Yellow Ochre
- Indian Yellow
- Bright Red

> "Every painting is going to be different, and that's what makes it great."

CANVAS PREPARATION

Use the 2-inch brush to cover the canvas with a thin, even coat of Liquid White. With long horizontal and vertical strokes, work back and forth to ensure an even distribution of paint on the canvas. Don't allow the Liquid White to dry before you begin.

Sky & Water

STEP 1

With Phthalo Blue on the 1-inch brush, use circular strokes to shape the blue sky area behind the clouds. Allow the light cloud shapes to remain unpainted. Use the top corner of a clean, dry 2-inch brush and circular strokes to blend the sky. The portions of the canvas that remain white will be the clouds, so try not to drag the blue into the white shapes as you blend.

Add Phthalo Blue to the same brush to underpaint the water with horizontal strokes on the lower portion of the canvas.

With a mixture of Titanium White and a very small amount of Bright Red on the fan brush, use tiny, circular strokes to paint the cloud shapes. Blend the clouds with the top corner of a clean, dry 2-inch brush, and then use sweeping, upward strokes to "fluff."

Mountain

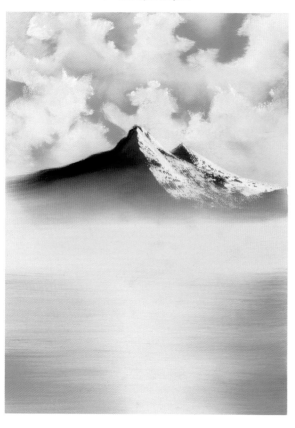

STEP 2

For the mountain, make a mixture of Midnight Black, Prussian Blue, Van Dyke Brown, and Alizarin Crimson. Use the technique on page 14 to paint the mountain. Highlight with Titanium White and a very small amount of Bright Red.

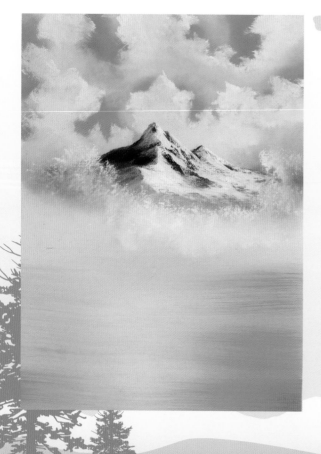

STEP 3

Use a mixture of Titanium White and Prussian Blue for the shadowed sides of the peaks. Again, refer to page 14.

With Titanium White on the 1-inch brush, use circular strokes to add the clouds at the base of the mountains. Still using circular strokes, blend with the corner of a clean, dry 2-inch brush, and then gently lift upward to "fluff."

Foothills

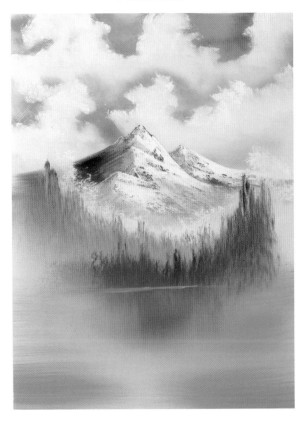

STEP 4

Load the 1-inch brush with a small amount of the mountain mixture, Sap Green, and Titanium White. Tap downward with the corner of the brush to shape the distant hills at the base of the mountain. Use the 2-inch brush to firmly tap the base of this first layer of hills, and then lightly lift upward to create the illusion of mist.

Working forward in layers, continue adding darker hills by using less Titanium White and adding more Sap Green and the mountain color to your foothill mixture. Hold the 1-inch brush vertically and tap downward to create more distinct treetops. Again, mist the base of the hills by firmly tapping with the 2-inch brush, and then lightly lifting upward.

When you are satisfied with your hills, use the darkest mixture on the 2-inch brush and pull straight down to reflect the hills into the water. Then lightly brush across to give the reflections a watery appearance. Use a mixture of Liquid White and a very small amount of Bright Red on the knife to cut in the water lines and ripples.

Evergreen Trees

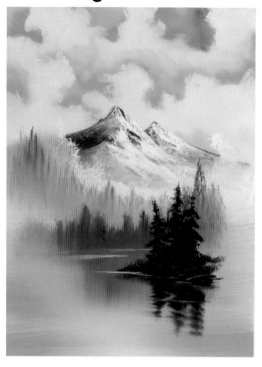

STEP 5

The evergreens are made with a mixture of Midnight Black, Prussian Blue, Van Dyke Brown, Alizarin Crimson, and Sap Green. See page 12 for instructions on painting trees. Use the same mixture on the fan brush to reflect the evergreens into the water and add the grassy area at the base of the trees. With the 2-inch brush, pull the reflections straight down into the water and lightly brush across.

Add the tree trunks with a mixture of Titanium White and Dark Sienna on the knife. Use the fan brush to very lightly touch highlights to the right sides of the branches and the grassy area at the base of the trees with a mixture of the dark tree color, Cadmium Yellow, and Yellow Ochre. Allow the evergreens to remain quite dark.

Use a mixture of Van Dyke Brown and Dark Sienna on the knife to add the banks along the water's edge, and then highlight with a mixture of Van Dyke Brown and Titanium White on the knife, using so little pressure that the paint "breaks." Cut in the water lines and ripples with a small roll of Liquid White on the long edge of the knife.

"You know me...I think there ought to be a big old tree right about here. And let's give him a friend. Everybody needs a friend."

STEP 6

Use the same dark tree mixture on the 2-inch brush to add the large evergreens.

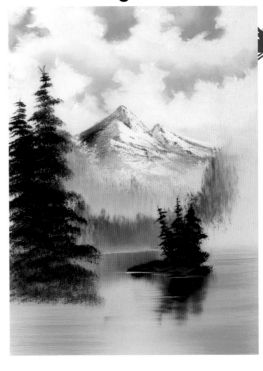

STEP 7

Underpaint the leafy trees and bushes in the foreground with the 2-inch brush. Extend this dark undercolor to the bottom of the canvas.

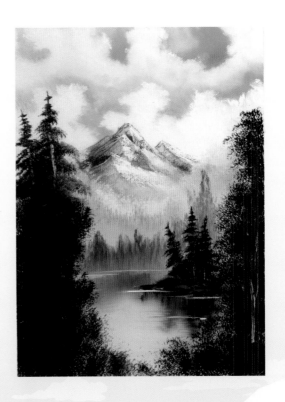

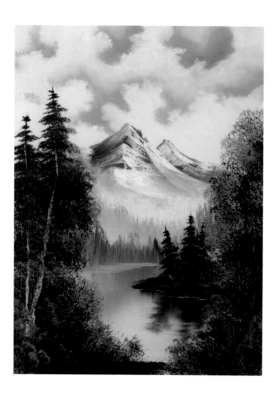

STEP 8

Use the point of the knife to scratch in the indication of tiny sticks and twigs, and then use a mixture of Van Dyke Brown and Titanium White on the knife to add the more distinct tree trunks.

To highlight the trees and bushes, dip the 1-inch brush into Liquid White, and then pull the brush several times (in one direction) through various mixtures of Sap Green, all of the yellows, and Bright Red to round one corner. With the rounded corner up, and starting at the top of each tree, lightly touch the canvas, forcing the bristles to bend upward. The color will automatically become darker as you work down toward the base of each tree. Try not to just hit at random; think about shape and form as you create individual leaf clusters, bushes, and trees.

Path

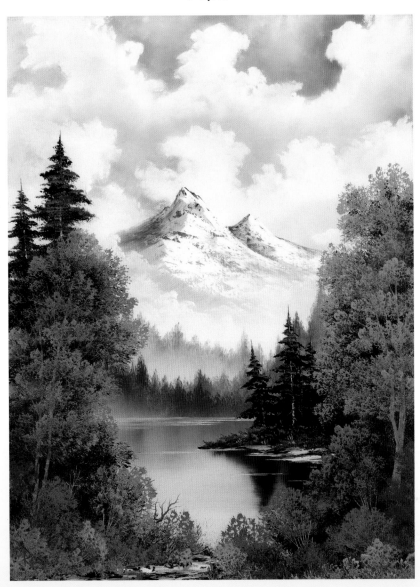

STEP 9

Use a small roll of Van Dyke Brown on the edge of the knife to add the path, and then highlight with a mixture of Van Dyke Brown and Titanium White, using so little pressure that the paint "breaks."

Finishing Touches

Use the point of the knife to scratch in small sticks and twigs, and your painting is ready for a signature.

DEEP FOREST
LAKE

BOB ROSS TOOLS & MATERIALS:

- 1-inch landscape brush
- 2-inch background brush
- #2 script liner brush
- Large knife
- Small knife
- Foam applicator or old brush
- 18" x 24" canvas
- Black Gesso

- Liquid White
- Alizarin Crimson
- Bright Red
- Cadmium Yellow
- Dark Sienna
- Indian Yellow
- Midnight Black
- Phthalo Blue

- Prussian Blue
- Sap Green
- Titanium White
- Van Dyke Brown
- Yellow Ochre

"There's enough unhappy things in the world. Painting should be one of those things that brightens your day."

CANVAS PREPARATION

Use a foam applicator or old brush to loosely paint in the general tree, bush, and ground shapes with Black Gesso. Allow the Black Gesso to dry completely before you begin.

STEP 1

With a mixture of Sap Green, Phthalo Blue, and Van Dyke Brown on the 2-inch brush, cover the black areas of the canvas with a thin, even layer of color. Cover the white portion of the canvas with a thin, even coat of Liquid White, allowing the Liquid White and the dark color to blend together at the edges. Don't allow the paint to dry before you begin.

Sky

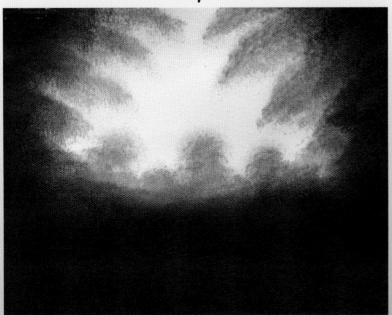

STEP 2

Load the 2-inch brush with a small amount of Alizarin Crimson and use small crisscross strokes to apply the pink areas in the sky. Without cleaning the brush, pick up a very small amount of Yellow Ochre and again use crisscross strokes to add this color to the sky.

Background Trees & Bushes

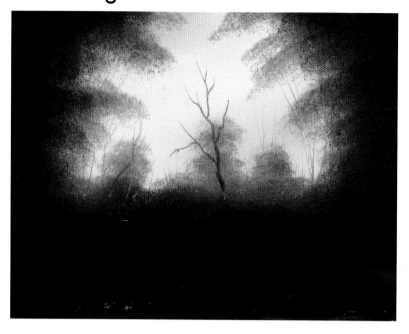

STEP 3

Use the 2-inch brush and the mixture of Sap Green, Phthalo Blue, and Van Dyke Brown to block in the basic background tree and bush shapes. Allow these shapes to remain soft and misty; this will help create the illusion of distance in your painting.

Then use the liner brush with thinned Van Dyke Brown to indicate tree trunks, limbs, and branches.

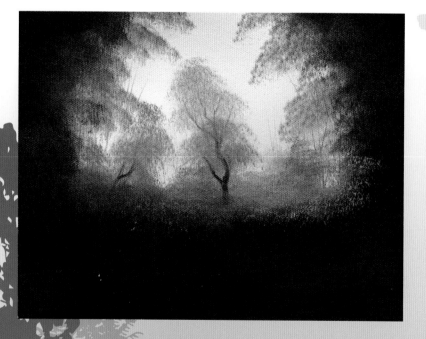

STEP 4

Highlight the tree and bush shapes with the 1-inch brush and various mixtures of the background tree color (Sap Green, Phthalo Blue, and Van Dyke Brown) and all the yellows and Bright Red. Using just the corner of the brush, tap in the individual shapes. Work in layers, completing the most distant areas first.

Water

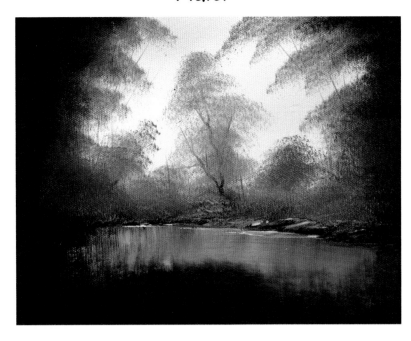

STEP 5

With Titanium White on the 2-inch brush, pull straight down to create the reflections. (Notice how the white paint mixes with the wet color already on the canvas.) Gently brush across to give your reflections a watery appearance.

Add the banks to the water's edge with Van Dyke Brown on the knife. Highlight with a mixture of Titanium White and Van Dyke Brown. Add the water lines with Titanium White and Phthalo Blue to complete the background.

"I don't try to understand everything in nature.
I just look at it and enjoy it."

Middleground Bushes

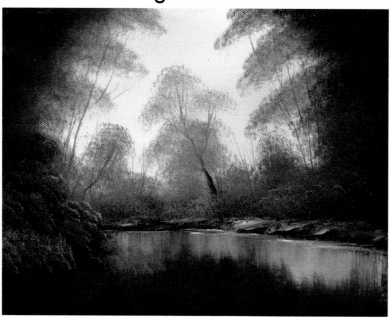

STEP 6

Moving forward in the painting, underpaint bushes by tapping downward with the 2-inch brush, using the same mixture of Sap Green, Phthalo Blue, and Van Dyke Brown. Add highlights to the bushes with various mixtures of all the yellows, Sap Green, and Bright Red on the 1-inch brush. Work in layers, being very careful not to "kill" all the dark underpaint.

"I can't think of anything more rewarding than being able to express yourself to others through painting."

Rocks & Foreground Trees

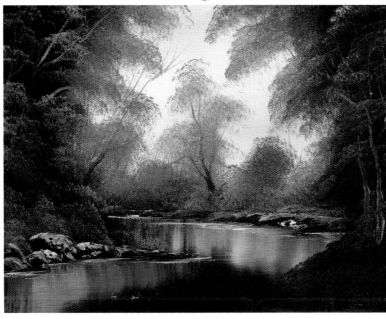

STEP 7

Again, with Titanium White on the 2-inch brush, add the reflections. Use Van Dyke Brown on the knife to add the large rocks along the water's edge, and then highlight with a mixture of Dark Sienna, Prussian Blue, and Titanium White on the small knife. Use a mixture of Titanium White and Phthalo Blue on the long edge of the knife to cut in the water lines and ripples.

Use a thinned mixture of Titanium White and Dark Sienna on the liner brush for the larger, lighter tree trunks. Add the leaf clusters to the larger trees with various mixtures of Sap Green, the yellows, and Bright Red. Just tap in the basic shapes with the corner of the 1-inch brush. Use the same mixtures to create small bushes at the base of the trees and again, pull down reflections.

Foreground Bushes

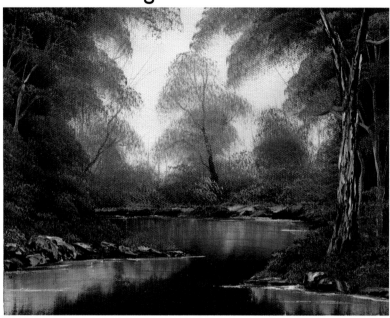

STEP 8

Moving forward in the painting, underpaint bushes by tapping downward with the 2-inch brush, using the same mixture of Sap Green, Phthalo Blue, and Van Dyke Brown. Add highlights to the bushes with various mixtures of all the yellows, Sap Green, and Bright Red on the 1-inch brush. Work in layers, being very careful not to "kill" all of the dark underpaint. Add the large tree trunk on the right.

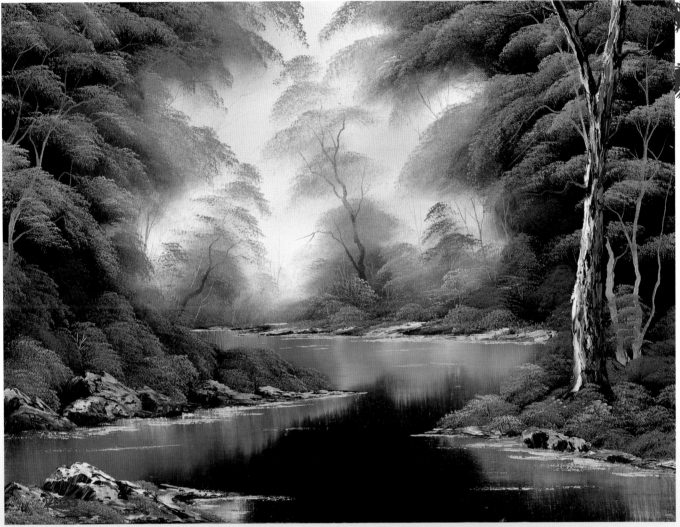

Finishing Touches

Form the large rock on the bottom left using Van Dyke Brown on the long edge of the knife. Highlight with various mixtures of Titanium White, Prussian Blue, Midnight Black, and Dark Sienna. Use the 1-inch brush with the yellow-green mixture to paint in some grassy areas, the 2-inch brush with Titanium White for reflections, and a mixture of Titanium White and Prussian Blue on the knife for water lines and ripples. Once you add your signature, the painting is finished!

WINTER MIST

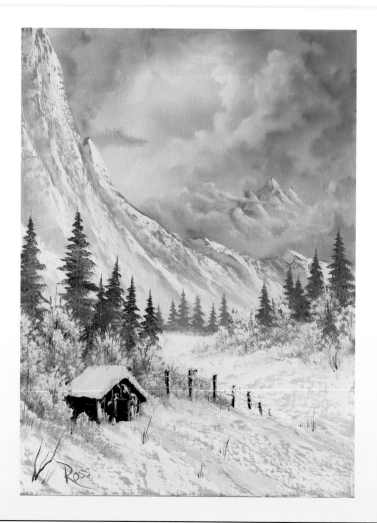

BOB ROSS TOOLS & MATERIALS:

- 1-inch landscape brush
- 2-inch background brush
- #6 fan brush
- #2 script liner brush

- Large knife
- 18" x 24" canvas
- Liquid White
- Bright Red

- Titanium White
- Prussian Blue
- Van Dyke Brown

"All you need to paint is a few tools, a little instruction, and a vision in your mind."

CANVAS PREPARATION

Cover the entire canvas with a thin, even coat of Liquid White using the 2-inch brush. Work the paint back and forth, up and down in long strokes to cover the canvas evenly. Do not allow the Liquid White to dry before you begin.

Sky

STEP 1

Combine Titanium White, Van Dyke Brown, and a small amount of Prussian Blue and apply this to the top of the canvas with the large brush, working in circular patterns to create basic cloud shapes. Starting with the most distant clouds, highlight the outside edges of the cloud with the fan brush and Titanium White blended with a very small amount of Bright Red. Use the large brush to blend the highlight into the cloud shapes, using tight, circular strokes. Complete one cloud at a time before moving on to the next closer one. Working forward, use less of the pinkish highlight color and graduate to pure white. To create depth in the sky, add gray clouds and blend together with the large brush.

Distant Mountain

STEP 2

Make the small mountain in the clouds with the large knife. Use Van Dyke Brown and Titanium White for the basic shape and highlight with a small amount of Titanium White. The cloud shadows are Prussian Blue and Titanium White. The mountain is very similar to the sky in color. You may soften these mountains even more by gently tapping with the large brush. Then add more clouds around the bottom of the distant mountains.

Large Mountain

STEP 3

Add the large mountain using the technique on page 14 and a mixture of Van Dyke Brown, Prussian Blue, and Titanium White. Remove all excess paint, and then use the large brush to blend the bottom of the mountains into mist. Continue using the large brush with a small amount of Prussian Blue and paint the lower portion of the canvas with horizontal strokes.

STEP 4

Apply highlights to the larger mountain with the knife and Titanium White, and shadows with a mixture of Titanium White and Prussian Blue.

Middleground Trees

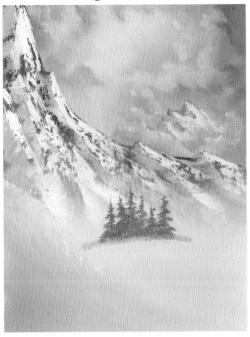

STEP 5

Paint the trees in the middleground and foreground. As you paint the closer trees, reduce the amount of white so the trees get progressively darker. Also paint the closer trees larger. See page 12 for details on painting trees.

STEP 6

After painting the closer trees on the right side, add bushes below them. First make a mixture of Van Dyke Brown, Titanium White, and Prussian Blue. Load the 1-inch brush by pulling it in one direction through the mixture to round one corner. Hold the brush vertically with the rounded corner up and push into the canvas to create the bushes.

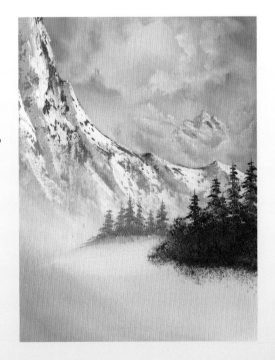

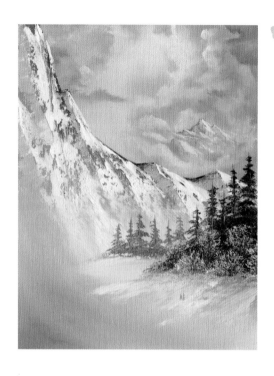

STEP 7

Highlight the bushes with Liquid White and Titanium White applied in the same manner. Then paint some snow-covered ground. Load the long edge of the knife with a small "roll" of Titanium White and use long, even strokes. Use very little pressure, letting the paint "break," which allows the darker color to create shadowed areas. Use the angles of the knife strokes to create the lay of the land.

Foreground Trees

STEP 8

Start with a mixture of Van Dyke Brown, Titanium White, and Prussian Blue mixed to a color almost the same as what you used to create the large mountain. Load the fan brush full of paint. Paint these evergreens on the left side. To create mist around the trees, use the large brush horizontally, tap the bottom, and then gently lift upward. Add additional leafy trees and bushes with snowy highlights.

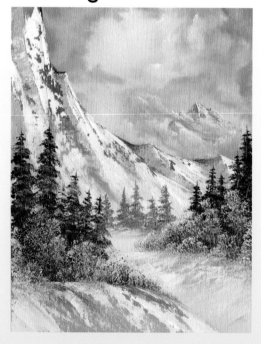

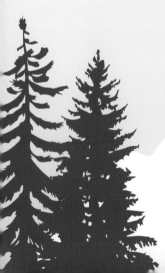

Cabin

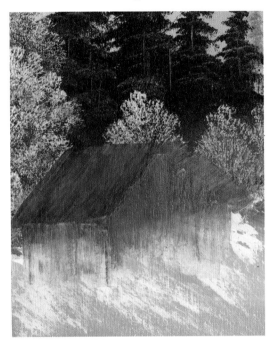

STEP 9

With the knife, remove paint in the basic shape of a cabin. This will help lay out your general shape and remove excess paint.

STEP 10

Paint the underside of the eave with the knife using Van Dyke Brown. Then paint the top of the roof with Titanium White on the knife. Be sure to follow the correct angles.

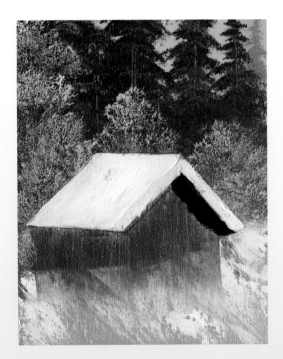

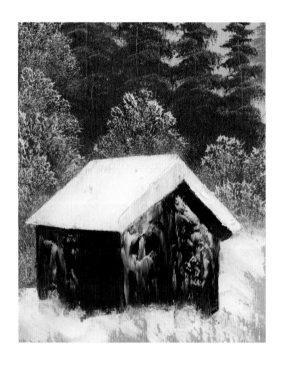

STEP 11

Apply Van Dyke Brown with downward strokes to create the front and side of the cabin. Small amounts of Titanium White may be added for highlights and to create an aged appearance.

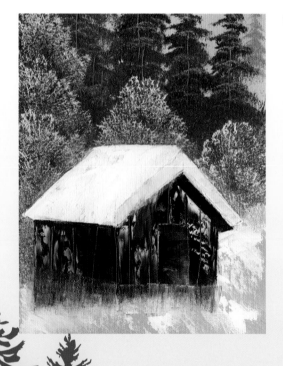

STEP 12

Add the door with Van Dyke Brown, pulling the paint sideways, and then highlight the edges with Titanium White. Cut in lines with the point of a clean knife to create the wooden planks.

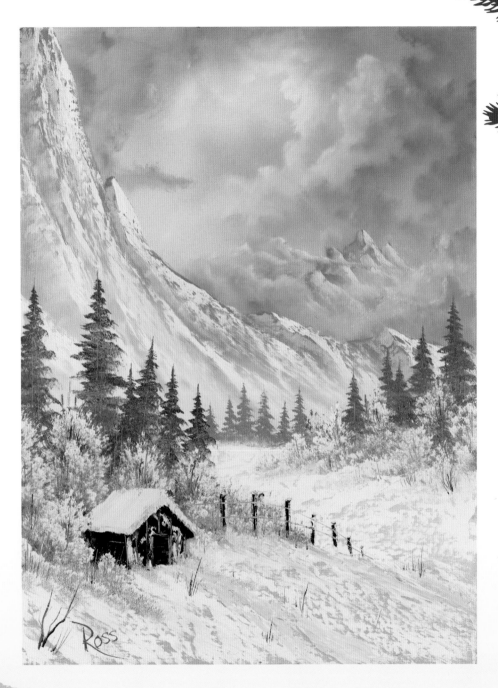

STEP 13

Add more bushes and snowy highlights around the cabin. Add the fence using the knife and Van Dyke Brown; then highlight with Titanium White. Make fence posts progressively larger as they near the foreground. Add the fence wire by cutting through the paint with the heel of the knife.

Finishing Touches

Use the point of the knife to scratch in small sticks and twigs, and your painting is ready for a signature.

FOREST RIVER

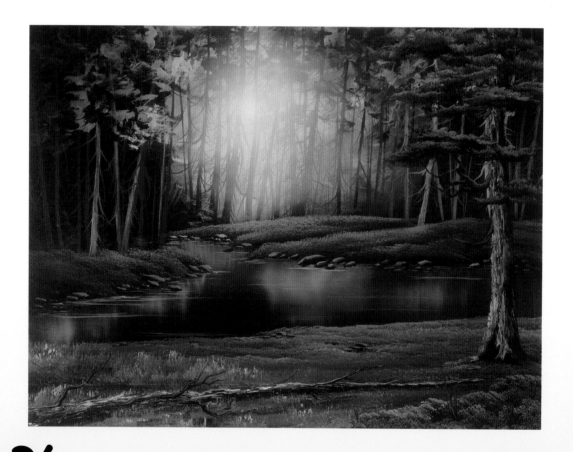

BOB ROSS TOOLS & MATERIALS:

- 2-inch background brush
- #6 bristle filbert brush
- #6 fan brush
- #2 script liner brush
- Large knife
- Foam applicator or old brush
- Black Gesso
- White Gesso

- Gray Gesso
- Liquid Clear
- Titanium White
- Phthalo Blue
- Prussian Blue
- Midnight Black
- Dark Sienna
- Van Dyke Brown

- Alizarin Crimson
- Sap Green
- Cadmium Yellow
- Yellow Ochre
- Indian Yellow
- Bright Red

"And that may be the true joy of painting, when you share it with other people. I really believe that's the joy."

CANVAS PREPARATION

Use a foam applicator or old brush to cover the canvas with a thin, even coat of Black Gesso. Allow the canvas to dry completely before you proceed. When the Black Gesso is dry, use a liner brush and Black, White, and Gray Gesso to create the shapes of the tree trunks, limbs, and branches above the horizon line. Again, allow the canvas to dry completely before proceeding.

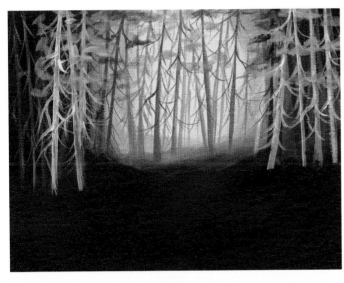

STEP 1

When your canvas has completely dried, use a 2-inch brush to cover the entire canvas with a very thin coat of Liquid Clear. (Liquid Clear should be applied very sparingly and really scrubbed into the canvas. The Liquid Clear will not only ease the application of firmer paint, but it will also allow you to apply very little color, creating a glazed effect.) Don't allow the Liquid Clear to dry before you proceed.

Sky

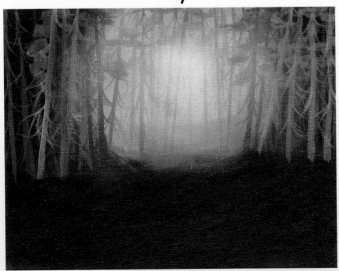

STEP 2

Load a clean, dry 2-inch brush with a small amount of Phthalo Blue and, working down from the top of the canvas, use crisscross strokes to begin painting the sky. Reload the 2-inch brush with a small amount of Prussian Blue and continue using crisscross strokes to darken the upper corners of the canvas. With Prussian Blue still on the 2-inch brush, firmly rub the bristles into the dark areas below the horizon, and then use horizontal strokes to blend the entire lower portion of the canvas.

Load just one corner of a clean, dry 2-inch brush with Titanium White and, working outward from the center, add the light area in the center of the sky. Blend the outer edges of the light source.

Grass & Water

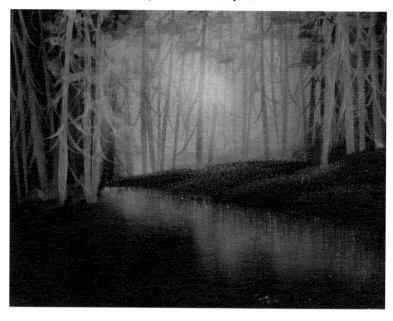

STEP 3

Load the 2-inch brush by tapping the bristles into a mixture of Midnight Black, Prussian Blue, Alizarin Crimson, Van Dyke Brown, and Sap Green. Tap downward to underpaint the grassy area at the base of the trees.

Use various mixtures of all the yellows to highlight the grassy area. Load the 2-inch brush by holding it at a 45-degree angle and tapping the bristles into the mixtures. Allow the brush to "slide" slightly forward in the paint each time you tap (this ensures that the very tips of the bristles are fully loaded with paint). Hold the brush horizontally and gently tap downward to apply highlights. Work forward in layers, carefully creating the lay of the land.

With a small amount of Titanium White on a clean, dry 2-inch brush, pull straight down from the grassy land area to paint the water. Lightly brush across to create a watery appearance.

"Just let your imagination go. You can create all kinds of beautiful effects, just that easy."

Rocks & Water Lines

STEP 4

Continue working forward with the grass and foliage at the base of the trees.

Use the knife to make a dark brown color on your palette by mixing Midnight Black, Van Dyke Brown, and Dark Sienna. Add paint thinner to the mixture to thin the consistency. Make a light brown color with the knife, using a mixture of Titanium White and the browns. Thin this mixture as well.

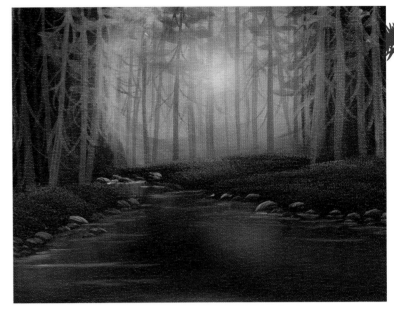

To paint the rocks along the water's edge, load the filbert brush with the dark brown, and then pull one side of the bristles through the light brown mixture. With the light side facing up, use a curved stroke to paint each rock. By double-loading the brush, you can highlight and shadow each rock with just a single stroke. Use the liner brush and a thin mixture of Titanium White and Phthalo Blue to add water lines and ripples.

Foreground Grass

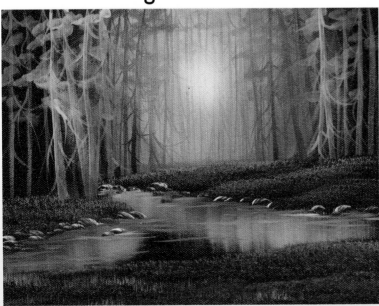

STEP 5

Extend the grassy areas into the foreground by first underpainting the land with the dark foliage mixture on the 2-inch brush. Without cleaning the brush, reload it with various mixtures of the yellows to apply highlights to these areas. Create taller patches of grass by giving a slight upward "push" to the brush. Remember to work in layers and follow the lay of the land.

Large Tree & Fallen Trunk

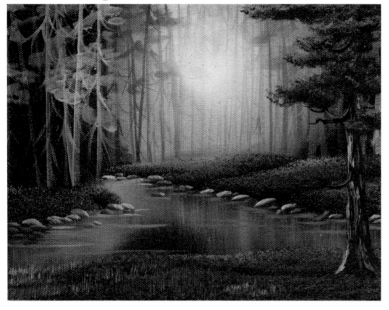

Load the fan brush to a chiseled edge with a mixture of Van Dyke Brown and Dark Sienna. Holding the brush vertically, touch the canvas at the top of the tree and pull down to paint the trunk of the large foreground tree. Highlight the left side of the trunk with a thin, light brown mixture on the filbert brush. Use thinned Van Dyke Brown on the liner brush for small limbs and branches.

Underpaint the foliage of the tree with a dark Midnight Black, Prussian Blue, Sap Green, and Alizarin Crimson mixture on the fan brush. Without cleaning the brush, reload it with the yellows to apply the highlights with an upward "push."

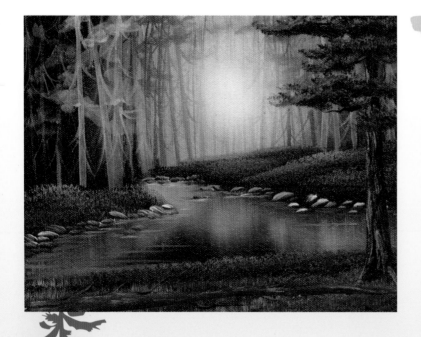

Load the fan brush with the dark tree mixture and, holding the brush horizontally, shape the fallen tree with a sweeping, horizontal stroke. Reload the brush with a brown-white mixture and highlight the top edge.

Again, use thinned Van Dyke Brown on the liner brush to add small limbs and branches to the trunk. Highlight the limbs and branches with a thinned mixture of Titanium White and Van Dyke Brown on the liner brush.

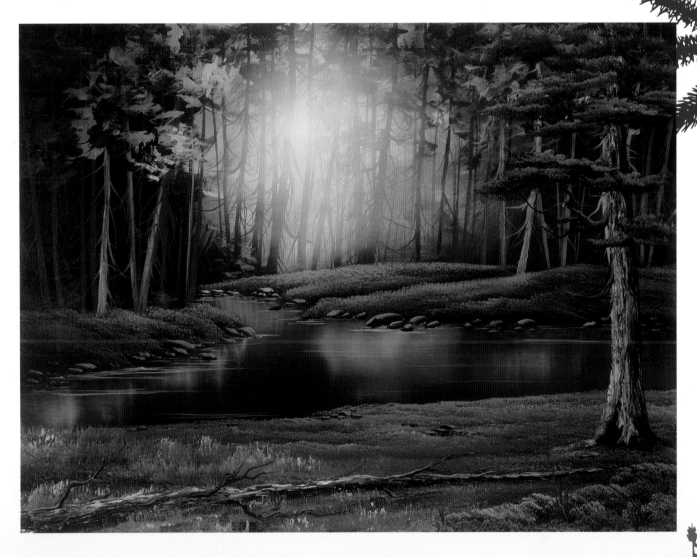

Finishing Touches

Use the dark foliage mixture on the 2-inch brush to underpaint bushes at the bottom corners of the canvas. Add Yellow Ochre and a very small amount of Bright Red to the 2-inch brush and touch highlights to the bushes.

Use thinned brown mixtures on the liner brush to make the indication of small sticks and twigs, and then use dark and light brown on the filbert brush to make the last rocks and stones. Paint on your signature, and your masterpiece is complete!

PAINTING WITH
BOB ROSS®

"I look forward to seeing you again.
Happy painting, and God bless, my friend."